Donated
To The Library by

John
Heidersbach

© DEMCO, INC. 1990
PRINTED IN U.S.A.

painted
worlds

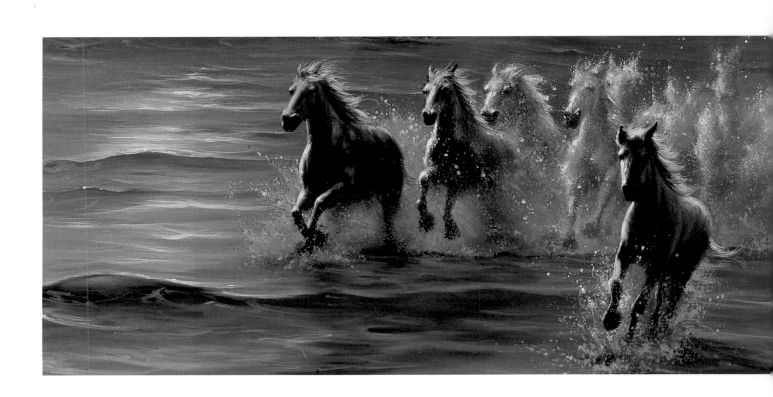

JIM WARREN
painted
worlds

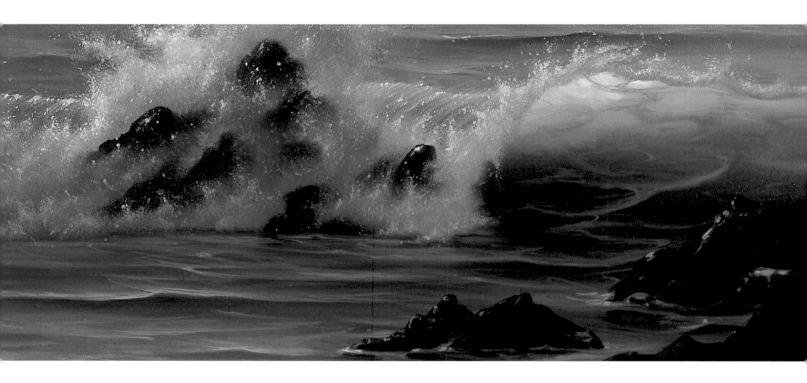

First published in Great Britain in 2001 by Paper Tiger
an imprint of Collins & Brown Limited
London House
Great Eastern Wharf
Parkgate Road
London SW11 4NQ
www.papertiger.co.uk

Distributed in the United States and Canada by Sterling
Publishing Co, 387 Park Avenue South, New York,
NY 10016, USA

2 4 6 8 9 7 5 3 1

British Library Cataloguing-in-Publication Data: A catalogue
record for this book is available from the British Library.

ISBN 1 85585 894 0 (hb)
ISBN 1 85585 908 4 (pb)

Editor: Paul Barnett
Designer: Paul Wood

Reproduction by Global Colour, Malaysia
Printed and bound by L-Rex Printing in China

For more information on Paper Tiger titles and to view stunning
images from the very best artists in science fiction and fantasy
art, visit the Paper Tiger website at:
www.papertiger.co.uk

Author's Acknowledgements:

With special thanks to: my parents Don and Betty, my wife
Cindy and daughter Drew, stepdaughter Rebecca and son Art,
and all my relatives far and near whose love and support has
driven me. Also many thanks to Wyland and the Wyland
Galleries crew, who have created a beautiful environment in
which to show my art, and to my fellow artists whom I toured
with: Walfrido, Coleman, Tabora, Hogue, Pitre, Mackin, Deshazo
and Wyland. My personal assistant Pat LueFan, Jane Frank of
Worlds of Wonder, Ed Kennedy, Ron King and Jona-Marie Price.
My friends, fans, collectors and models and to L. Ron Hubbard
for his continued inspiration.

Also, many thanks to the team at Paper Tiger: Paul Barnett,
Katie Hardwicke and Paul Wood.

www.jimwarren.com

PELE RISING

(right)

While in Hawaii for some art shows in 1994 I learned
about Pele, the Hawaiian goddess of the volcanoes.
Although the painting was inspired by this visit to Hawaii,
it has been pointed out to me that it also has a certain
Californian flavour, particularly in the appearance of the
woman. I think all of the paintings I do have to some
extent a blend of influences drawn not just from that
moment but also from other times in my life.

1996

24in x 36in (61cm x 91cm)

Available as limited-edition prints

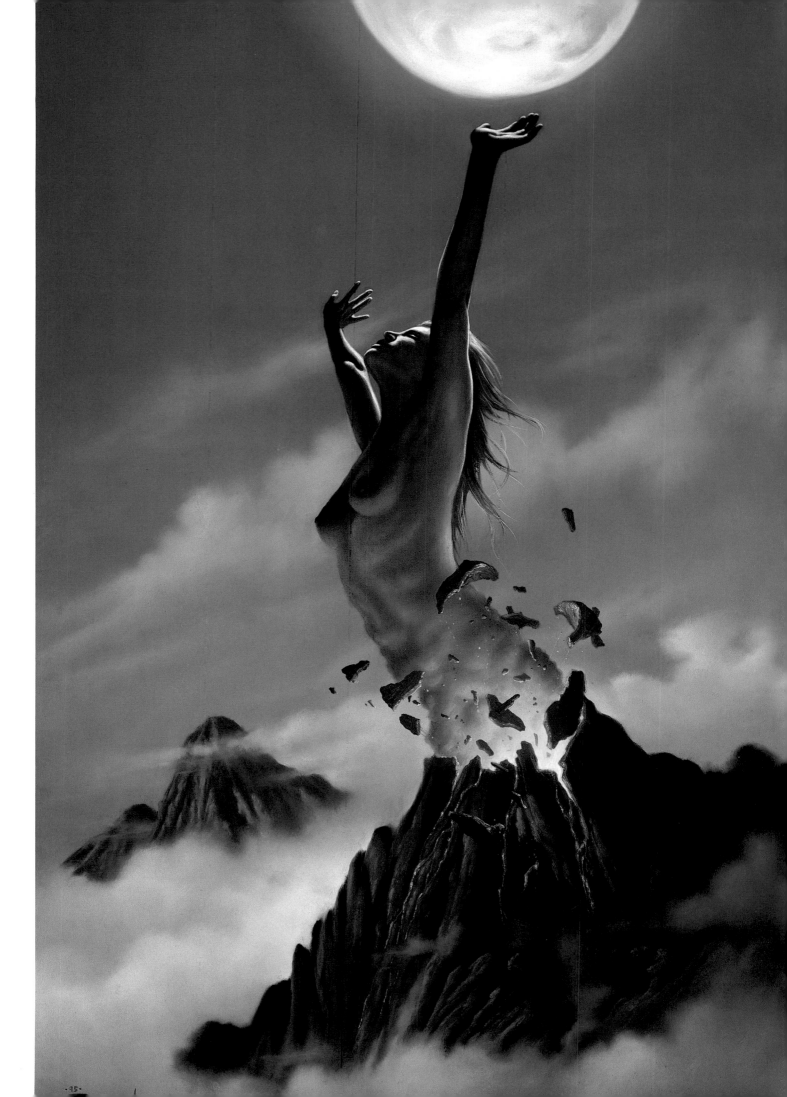

introduction

PEOPLE OFTEN ASK ME IF I WAS an artist as a child, and my answer is always the same: 'Sure I was!' *Everyone* was an artist as a child. The only difference between people like me and the rest of the world is that some of us just never stopped.

I guess you could say that I was an artist from the time I learned to hold a crayon. I wasn't a very *good* artist in those days, of course, but then I wasn't having to think about the business side of art either. And the pictures looked just fine to me. As a two-year-old, with a two-year-old's limited vocabulary, I had discovered a way to communicate. That small white square of paper was my world. I could escape into that world almost whenever I wanted to, and once in it I could do just about anything my heart desired. Those scribbles of colour were in a very real sense the first of my painted worlds.

Other artists often talk about their traumatic or arduous – or at least interestingly unusual – early childhoods, but mine was nothing like that. I was the beaver from the *Leave it to Beaver* television show, living in a Norman Rockwell painting. My father, Don, was a supervisor at the Ford Motor Company; my mother, Betty, took care of myself and my big sister and brother, Kathy and Rick. We lived in Long Beach, California. We had a dog called Sissy. My grandma lived in a house behind us, and we would often gather for dinner, watch TV or go on family trips in our Ford station wagon.

One of my earliest inspirations was a day we all spent at Disneyland. There I found a place filled with exuberant life and bright colours. Everywhere I looked there were stimuli for my young imagination. I can remember wondering, 'Why isn't school like this? Why are all the houses where we live white or pastel-coloured, and why are they all the same sort of shape? Why aren't they all different from each other? Why isn't there a train at home you could catch and go off to find strange adventures in even stranger places?' And so on and so on. Again, I guess all of us think like this when we're children, and again it's a matter of some of us 'learning better' – learning to focus on nothing but the real world and dismissing our fantasies as something irrelevant. Others of us, of course, just never stop thinking that way: we may never be able to go to the places or see the scenes we can imagine, but that doesn't make them any the less real for us.

Another early influence I can remember came when I was maybe five years old. My grandma had just bought a brand-new colour television, and I was allowed to watch what must have been the first TV screening of *The Wizard of Oz*. This was full of emotions and imagination and subtle messages, and it had a profound effect on me. Certainly it was an inspiring change from the Looney Tunes cartoons that had been my staple fare up until then! By this age I had already advanced from the coloured scribblings of my younger years to drawing things like giant butterflies chasing soldiers or dragons rescuing children – the usual childhood stuff, I suppose, though maybe it's interesting that I was already so fascinated by fantasy subjects. That's not to say there weren't any 'real world' influences that played their part: among the experiences that left an impression on me were visiting

the nearby beaches of sunny California and going on family trips all over the United States, seeing rivers, deserts and mountains – the pure, simple beauty of Mother Nature.

All in all, as I say, my childhood wasn't particularly unusual – except for the way that I saw reality around me. Basically, there were two worlds I lived in. First there was the world I could reach out and touch, the same world that everyone else lived in and could see; it was safe and simple, and quite honestly there was nothing much in it for the young Jim Warren to complain about. But the other world, though just as real to me, was very different. It was the world of the imagination. This second world I could see the way I wanted it to be, and I could change anything about it that I didn't like. I could make this world anew simply by waving my magic brush and painting it accordingly. And, while the mundane world around me was very nice, of course, I thought it too could maybe do with a little bit of spicing up.

This process of 'spicing up' would eventually result in the emergence of my painted worlds.

When I was seven I made a career choice: I was *definitely* going to be an artist. I saw a newspaper ad for an art competition and decided to go in for it. You had to copy a cartoon, so I did that and sent my entry off. I didn't think I had much chance, but a month later a man called and told my father I was the winner. My prize was a free art class.

The trouble was, by then I'd decided I *definitely* wanted to be a stage magician …

It was in about 1967, while I was still in high school, that I really decided I was going to be an artist. That was the year I was told I'd flunked my art class because I wasn't fulfilling my assignments properly – instead I was 'drawing weird things'. This didn't discourage me a great deal, to tell you the truth, since I was already selling drawings to my classmates for 25 cents a time. This was the era of psychedelia, and so I was doing some psychedelic pictures as well as some surreal ones – I can still remember my first encounter with the paintings of Salvador Dalí and the tremendous rush of *freedom* I got when I realized, looking at them, that, to hell with the rules, *I could paint anything I wanted to*. I was developing my own style of drawing mainly by working not in the school art classes but at home – and sometimes even in maths classes as well. Soon my parents began to believe my artistic talent had potential; the maths teacher said he was pretty impressed too.

My parents bought me my first set of paints around this time – oil paints. I've used only oils and paintbrush ever since.

So I wanted to be a Great Painter – but was there hope? I was determined I was going to make it. It wasn't really the time of life or the time of history when people made big decisions and stuck to them – I was a kid in high school in Southern California during the 1960s, so life was full of fears and confusions and excitements and girls – but I was resolved to be the one guy who achieved what he set out to do. My goals were partly selfish, I'll admit it: I wanted to be rich and famous. But also there was the part of me that felt very much as if I'd been given a mission to liven up and inspire what I sometimes saw as a rather dull and meaningless world. When I was painting I was performing like a musician on a stage; I was making music for the eyes. I could almost hear the applause after I finished what I felt was a great picture …

And in the meantime I had to get a 'real' job or join the army. All around me people were freaking out on drugs and fighting and rioting and protesting and things. They were using weird catch-phrases like 'Keep on Truckin' and 'Peace Brother', while the adults were telling us: 'Get a haircut!' It was a lot of fun for a kid fresh out of high school, and there was plenty of artistic inspiration … though I also saw that the drugs so many people were taking were destroying all that. I realized very early on that drugs can make people *feel* like they're being creative, but in fact what the drugs are doing is stifling real creativity. I was too dedicated to my goal of being a painter to want to risk losing my talent to drugs.

I knew exactly where I was going and the style in which I wanted to paint, and I didn't think I needed any training from anyone else – just a few books to tell me the basics, like which colours to mix together to make a good purple. I already had artistic influences in the form of Dalì, Norman Rockwell, Andy Warhol, Rembrandt and others; I was also getting a lot of inspiration from the music of groups like the Beatles and the Beach Boys. You must remember I was still only 18 years old at the time, so I was not especially sophisticated about the effect I wanted my paintings to achieve: I wanted them to have a dramatic realism, enhanced by lighting and shadows, and at the same time, to varying degrees, a whimsical surreal twist. All in all, a short catalogue of characteristics all designed to make people look at my pictures and say: 'Wow!' – that was as intellectual a critique as I then wanted. I'm not so sure, to be honest with you, that my objectives have changed all that much over the decades …

My early paintings often focused on subjects ranging from war to religion to sex to politics to growing up – all of them subjects I observed in life and was curious about but knew little of at the time, except the last. That didn't matter, though: I was an *artist*. They were *paintings*. I could do exactly what the heck I wanted in the expression of my art. I was *young* and a *rebel*. And I truly believed that I was doing something *important*, that I was on a mission to *change things* – and that I *could* do that. I was a teenager ready to take on the world.

Perhaps you've been there yourself.

In due course my opinions altered, especially my view of my own importance, and I came to realize that I could achieve both less and more than my youthful self had conceived. There were some rocky patches along the road to this realization, of course, not least those times, early on, when I became engrossed in my own career to the extent that I totally ignored the world around me and in particular the simple matter of getting a life. In the first few years of my career I received what I now recognize as far too much attention and success, culminating in my winning in 1975 the First Place Award at my very first professional showing: the Westwood Art Show. This event was the second largest of its kind in the United States: about four hundred artists were exhibiting and the attendance was something like a hundred thousand. In one sense this was the attainment at an astonishingly early age of all my dreams and the best thing that could ever have happened to me; but in another sense it was a disaster for me, since it gave me the perfect excuse to 'live for my art' – and for nothing else. My painted worlds became the only world I had.

Luckily I soon realized that I'd upset the balance between real and imaginary worlds which was the key to my having become an artist in the first place. I had set out to spice up the world but had manoeuvred myself into a situation where I didn't have a world to spice up – a world of friends and family and experience. I had stopped observing. I was ignoring relationships. As it was once summed up so eloquently in a farewell letter to me: 'You ignored me for the world within your canvas.'

Luckily I soon woke up from this phase, and the lesson of it still remains with me even quarter of a century later. Any time I find myself getting too self-absorbed or taking things too seriously, I remember what it was like then and I grab the family and head for the mall or Disney World or maybe go for a nice peaceful trip to the beach. Although the painted worlds I can live in are every bit as real as this one, they cannot exist without it, just as I cannot exist without the people around me and my relationships with them. It's from friends and family and life's experiences that I get my inspirations. Without them there is nothing left of importance to paint.

During that quarter of a century my career has taken its fair share of twists and turns. Having started out as a fine artist, albeit a fine artist who early on was rejected by the orthodox galleries – 'Surrealism doesn't sell. Do Clowns. Clowns sell.' – I ended up for a time as primarily an illustrator, earning a reputation for my book jackets and other covers. In the early 1990s I returned to my fine-art roots. Those were the days when environmental concerns were in vogue, and coincidentally – or maybe not – my paintings were deeply reflecting those concerns; famous pieces of mine like *Mother Nature, Earth: Love It or Lose It* and *Natural Beauty* were created at this time. Many of these images

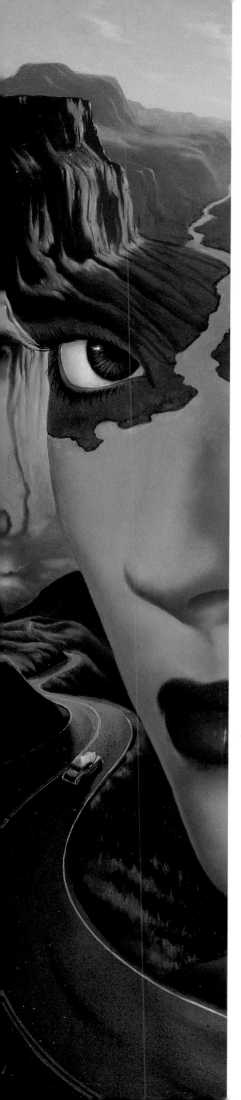

were used as visual symbols of the environmental movement on T-shirts, billboards and magazine covers. I was happy to see my art used like this and felt that maybe – in at least some small way – my painted worlds could have an influence on the real world as a return for the influence the world had had on the creation of those paintings.

By the mid-1990s my art had found a home in some of the finest art galleries in the USA: the Wyland Gallery chain. I had met Wyland, considered by many to be the top marine-life artist in the world, in 1991 at the Los Angeles Art Expo. He approached me and asked if I'd be interested in collaborating on some paintings and also if he could feature my art in his galleries. Some of those paintings are featured in this book, as are the stories behind them.

When I look back on my early days as a young and naive artist, and on the person I was then, so full of idealisms and confusions, I can see that a lot has changed – but at the same time I wonder, paradoxically, if anything has really changed at all. That small white square of paper I used to use as a child is now a large canvas, but it's still the same place: a world into which I can venture and in which I can do and communicate what I want. It's a place where children can ride dolphins, where women can become waterfalls, where breaking waves can become horses, where romance is to be found on every side. When the mood strikes me, this other world can become more wildly bizarre than a circus freak show or more beautiful than even Mother Nature herself. It's a world where anything can happen … and does – just the way it should be in our own world.

And you're welcome to join me in it. I hope you enjoy the show.

Now that I have children of my own, people obviously often ask me if they're artistically inclined like their father.

I reply: 'Of course they are. They're *children*, aren't they?'

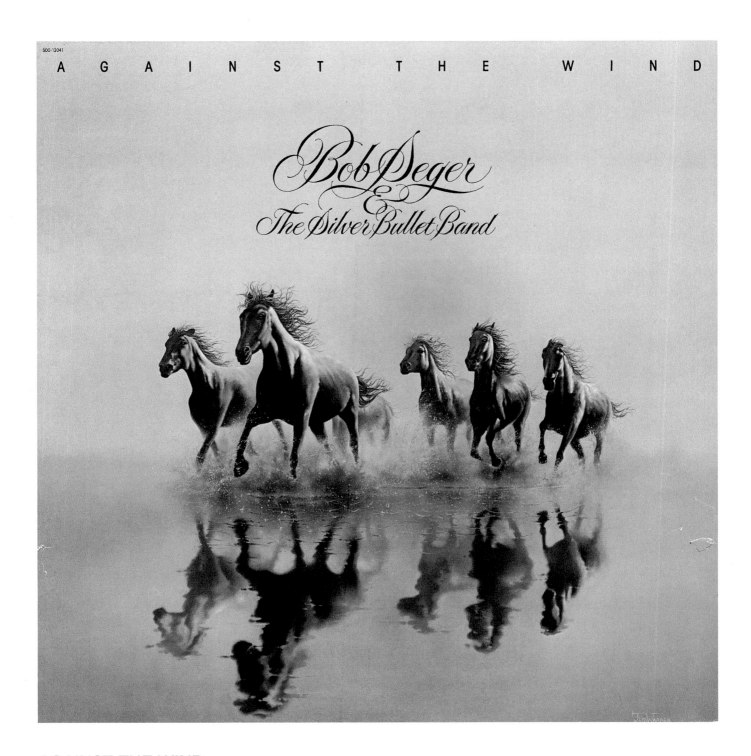

AGAINST THE WIND

Ten years into my career I sent photos of my work to the art department at Capitol Records. After several months of hearing no response, I assumed these pictures had gone into that black hole you can find in any art department: the trash can. However, a year and a half later I got a call from Capitol's art director, and to my surprise he told me Bob Seger wanted some horses painted for his new album *Against the Wind*: would I accept the commission? I was honest with him and said I didn't really 'do' horses – which, astonishing as it may seem today, was the case at the time: I painted mostly people. The art director said, 'You can do it', and so I did. A while later I was surprised again when this cover won a Grammy Award for Best Album Package. The painting was also used for billboard advertising in most of the major US cities. So I guess, if nothing else, I'd discovered I could 'do' horses!

1980 30in x 30in (76cm x 76cm)

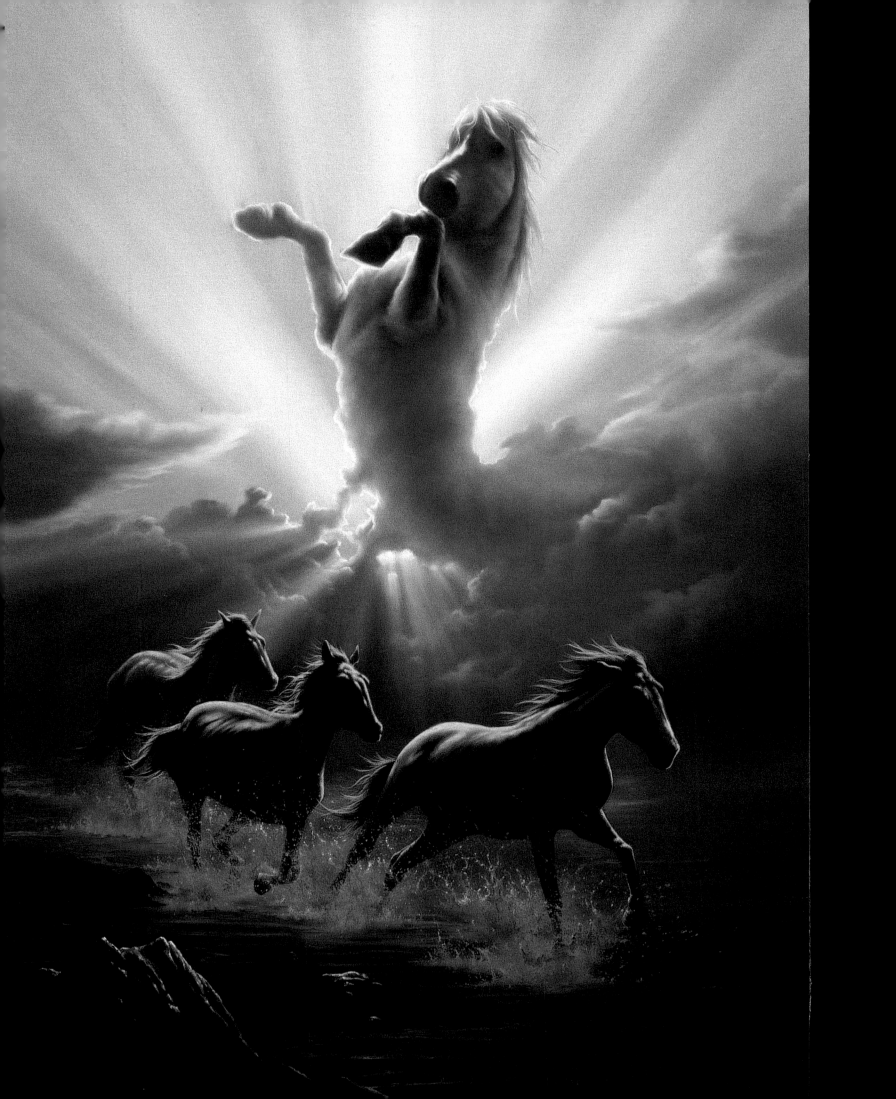

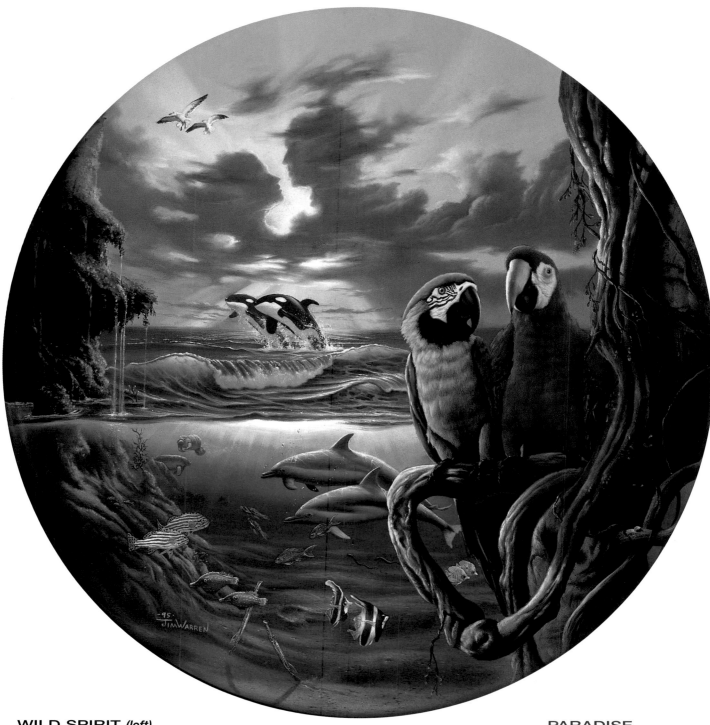

WILD SPIRIT (left)

Horses have always represented spirituality to me. Pictures of horses are among the most popular of my paintings – people readily buy the originals and the limited-edition canvas prints while reproductions are used for greetings cards and puzzles anc in all sorts of other media. It may seem paradoxical to talk of a subject in the same breath as both spiritual and commercial, but perhaps, in looking at horses, other people sense and yearn for the same spirituality that I do.

1994

24in x 36in (61cm x 91cm)

Available as limited-edition prints, greetings cards

PARADISE

The obvious theme of this painting is: *Love Makes the World go Round.*

1995

30in (76cm) diameter

Available as limited-edition prints, puzzles, other gift products

MARTIN SHEEN

I painted this portrait for the cover of a book that was never published, probably because it was based on a movie that was never released. However, I still like the painting because it strikes me as a good example of pure photo-realism.

1987

24in x 36in (61cm x 91cm)

THEY WALKED LIKE MEN *(right)*

This was done as a cover illustration for the 1986 Avon edition of the novel by Clifford D. Simak. It's hard to imagine that I did cover illustrations for over two hundred books without ever having gone to art school. Now that I'm no longer an illustrator I can admit a dreadful truth: I never read any of the books I illustrated. I felt that I needed to know only the basic story, as conveyed in a few descriptive pages from the editors, to paint the one picture that would represent the whole book.

1986

20in x 30in (51cm x 76cm)

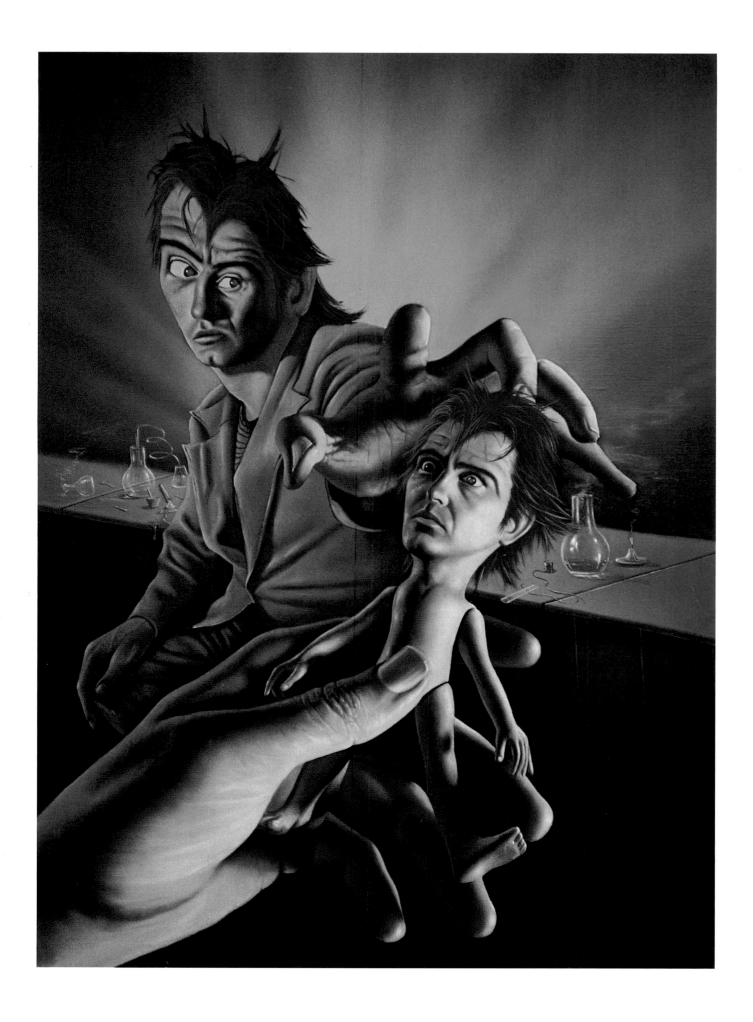

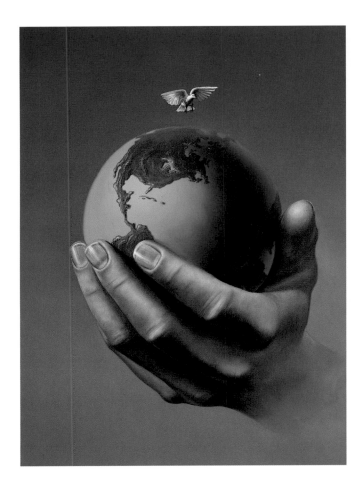

HELPING HAND

It's an old cliché that a picture's worth a thousand words. Someone once qualified it by adding that, the simpler the picture is, the more words it's worth. *Helping Hand*, one of my environmental-awareness paintings, is certainly conceptually simple enough, and its popularity over the years would suggest that indeed it's worth more than the standard thousand words.

1995

24in x 36in (61cm x 91cm)

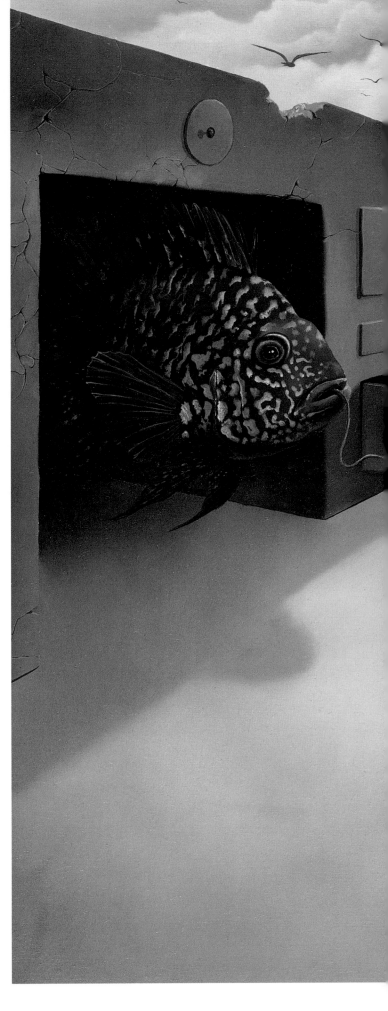

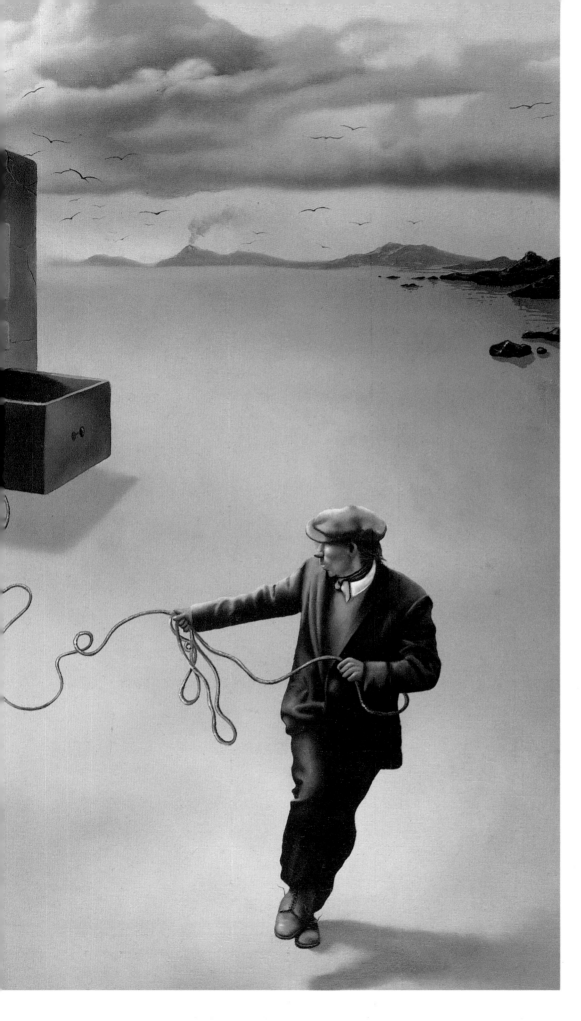

GONE FISHING

This is a very early painting, done before I'd decided that I was going to become a full-time artist. At the time I was contemplating the horrific prospect of having to get a 'real' job, and felt I needed a vacation already ...

1976

22in x 28in (56cm x 71cm)

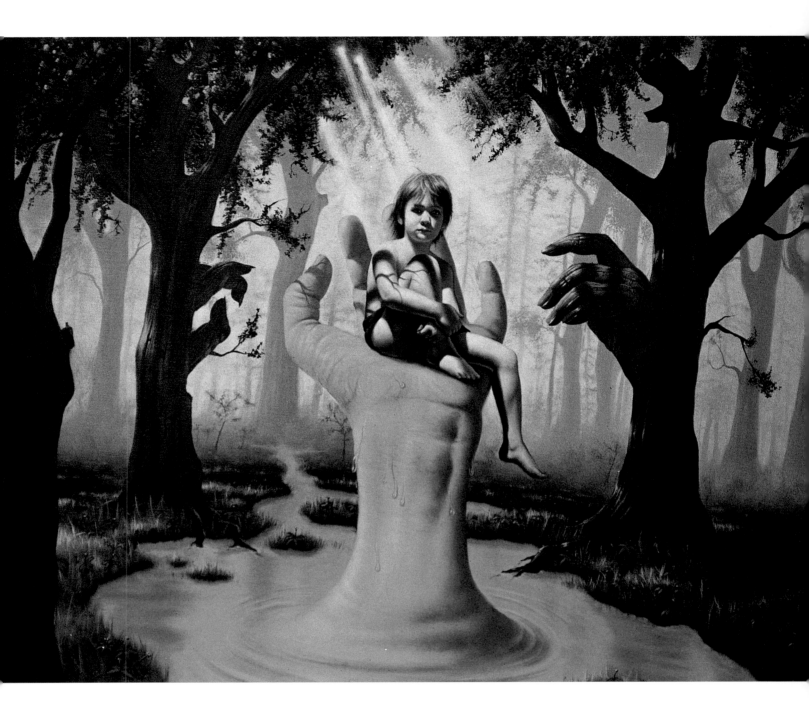

RUMORS OF SPRING

Cover for the book *Rumors of Spring* by Richard Grant,
published by Bantam Spectra.
1988
18in x 24in (46cm x 61cm)

SHOW OFF *(right)*

I remember as a child doing any silly thing I could to get
some cute little girl's attention. It was those memories that
sparked off this picture.
1992
24in x 36in (61cm x 91cm)

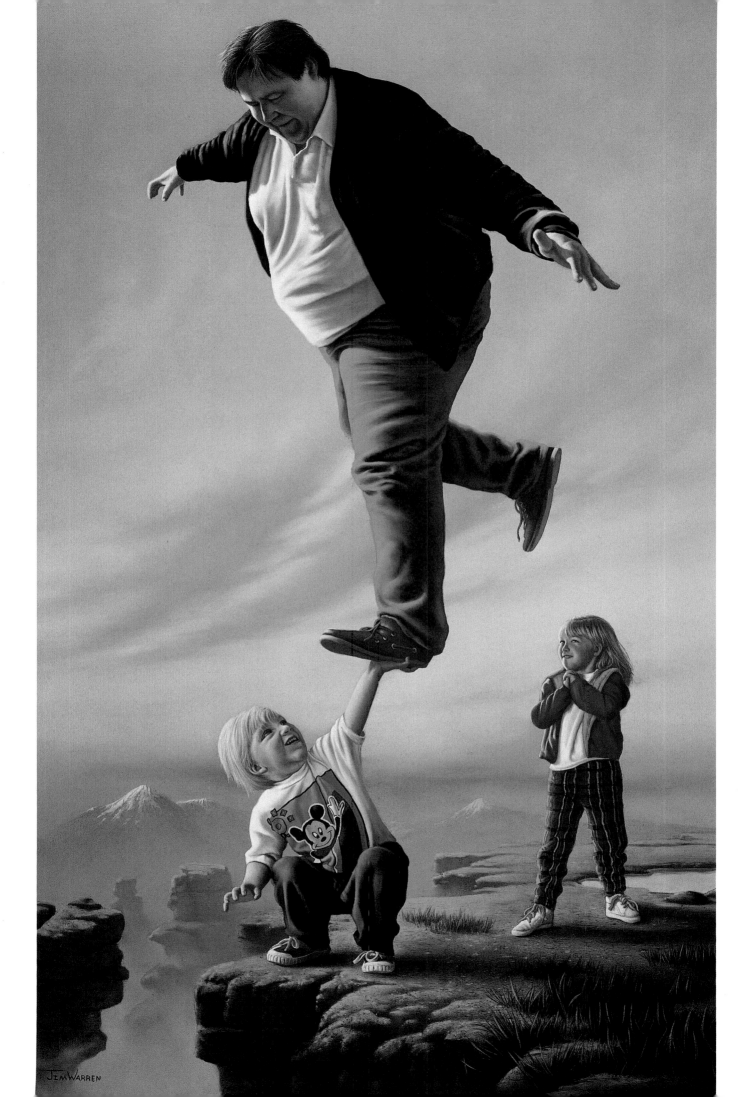

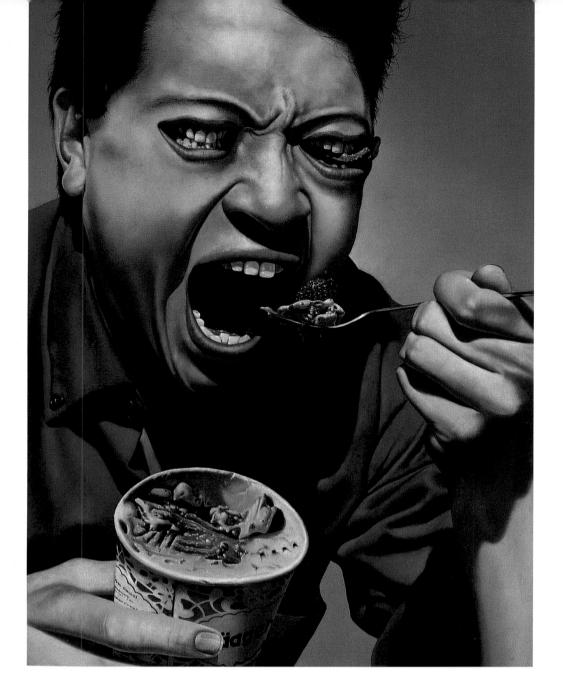

ICE CREAM MAN

This is probably the most intensely disturbing painting I've ever done, and all over a simple little statement about my love for Häagen Dazs ice cream. It's also a statement about the only vice of mine I'm prepared to admit to in public: sugar. It's interesting how some people see this as funny and others see the same thing as horrific.

1986

22in x 28in (56cm x 71cm)

MOBILE HOME *(right)*

I used to do many more paintings like this one: surreal and laced with humour. The fact that my art has moved away from this style doesn't mean that I'm no longer proud of those paintings – far from it: I feel about them like a parent whose children have grown up and are now out in the world on their own.

I've been planning for some time now to do a 'remake' of this picture – just in the same way as people do remakes of movies in light of the technical improvements that have happened over the years since the original was made.

1993

24in x 36in (61cm x 91cm)

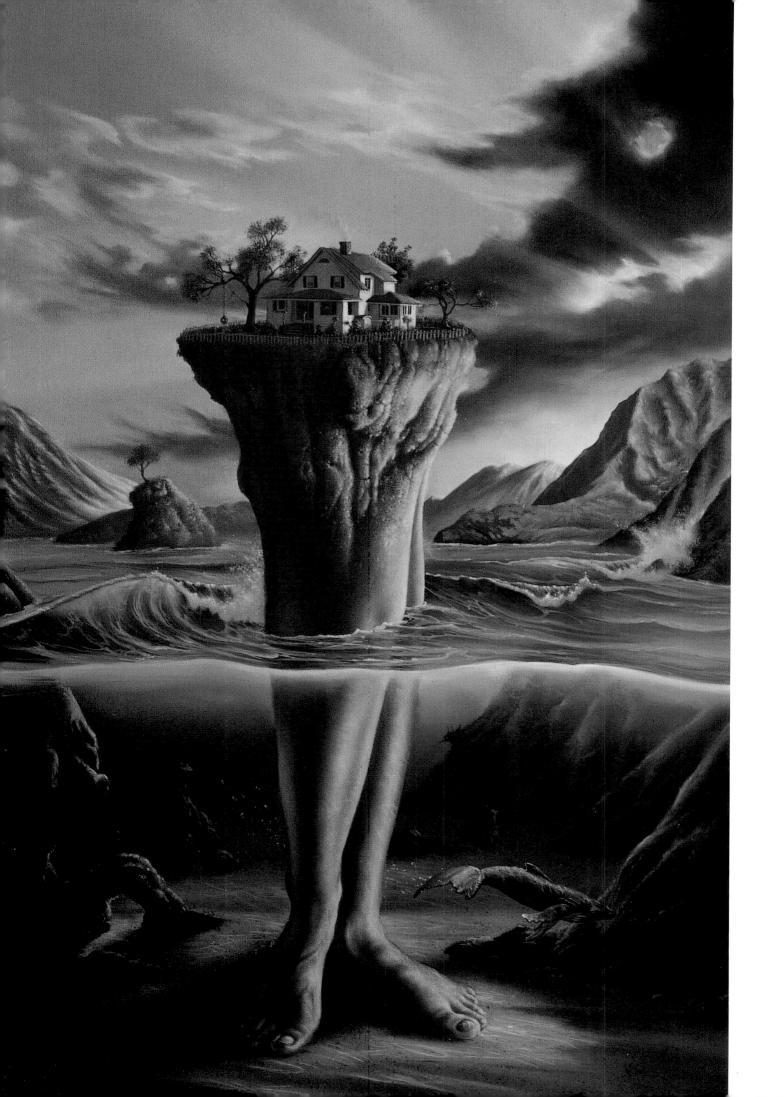

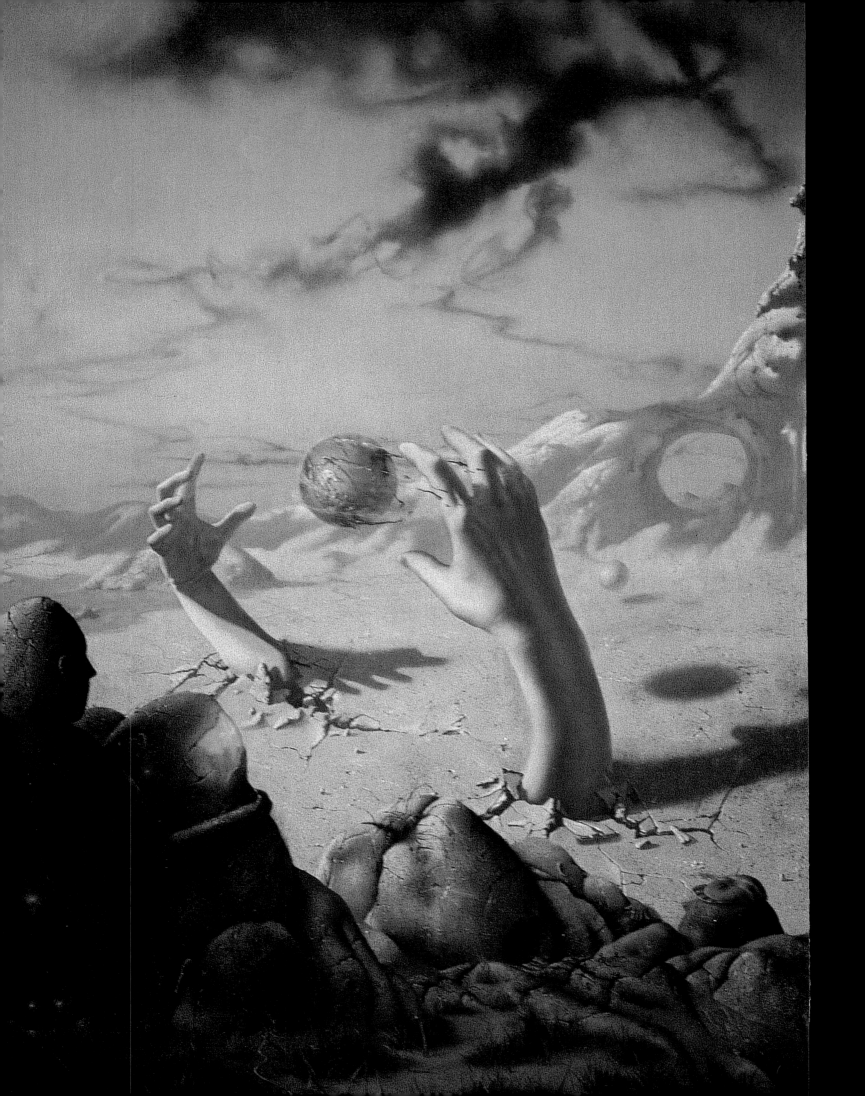

SPACE GAMES

(left)

Over the years I've done my fair share of experimenting, and have gone through various artistic phases. This painting dates from the period during the mid-1980s when I was trying my hand at science-fiction art. I had a lot of fun doing it.

1985

24in x 30in (61cm x 76cm)

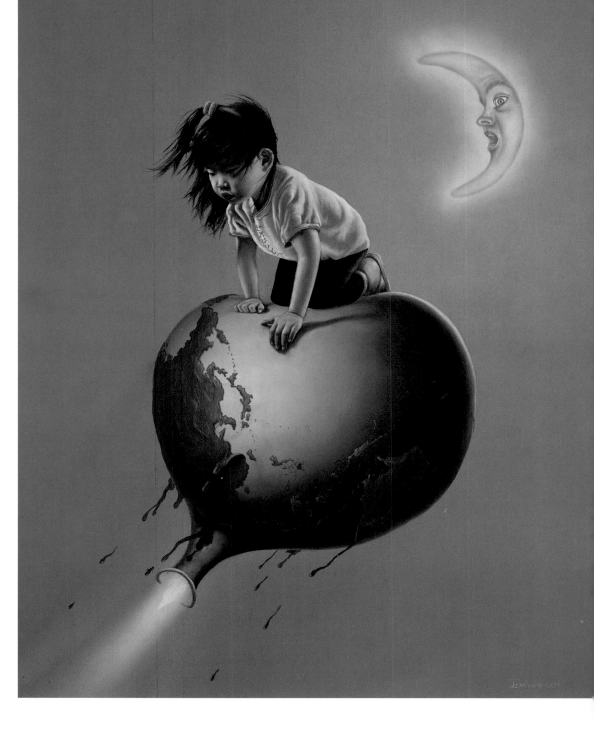

EARTH: LOVE IT OR LOSE IT

(Japanese version)

In 1989 I did a painting called *Earth: Love It or Lose It* that became an icon for the environmental movement: it appeared all over the world on T-shirts, posters, magazine covers and even billboards looming over the highways of my native USA. As a result, I found myself being fêted by the environmental movement; more important, my own sensitivity to the environment and conservation increased dramatically. A while later I did a Japanese version of the painting, which is the one shown here.

The hardest part was getting the motto translated into Japanese for the little girl's shirt. 'Earth: Love It or Lose It' translated conceptually to 'World One', which is what you see written here.

1993 24in x 30in (61cm x 76cm)

FEARLESS

Many of the ideas for my paintings come from observations of people or the experiences I had growing up, or from seeing some beautiful location that just cries out for me to re-create it on canvas. This painting came about after I saw my daughter Drew, then aged 2, run playfully towards a big growling dog, unaware that there was anything to be fearful of.

1982

24in x 30in (61cm x 76cm)

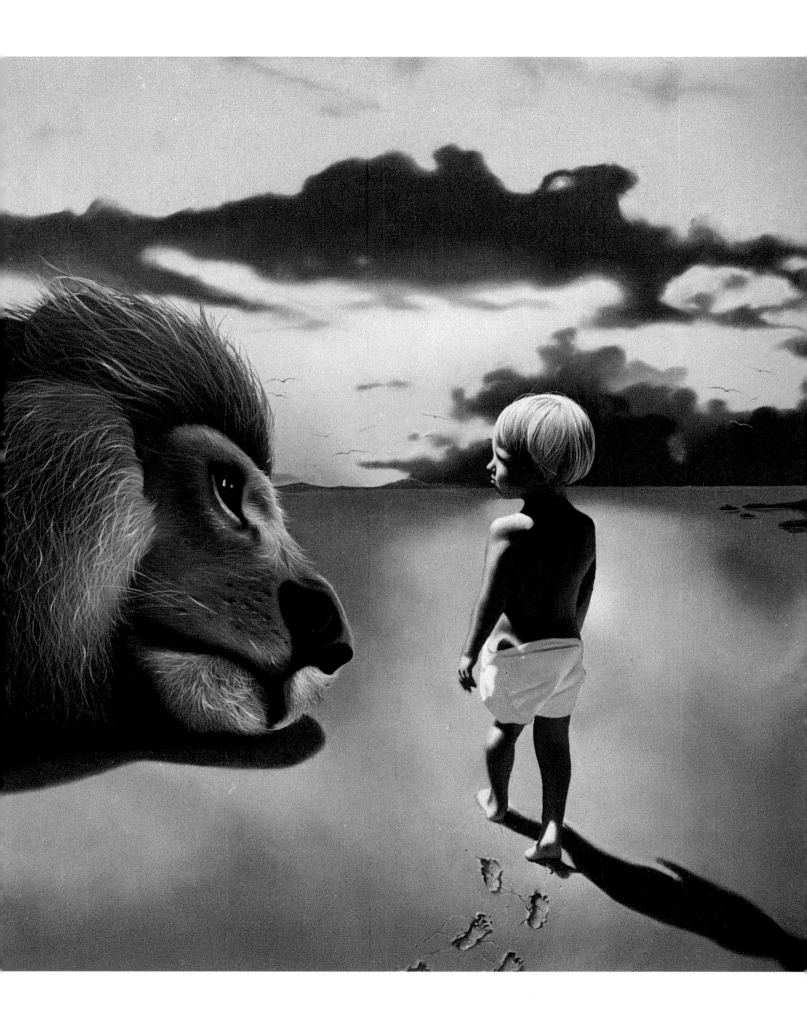

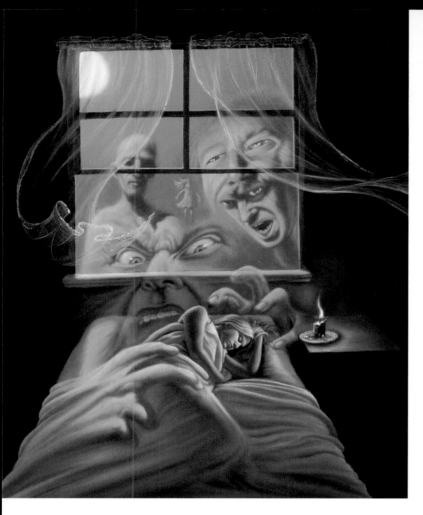

PHANTOMS OF THE NIGHT *(above)*

Sometimes I paint a picture upside-down. This is to stop myself thinking too much about the subject matter so that I can concentrate on the design and colours. (I also often look at a picture in the mirror to get a fresh perspective on it.) This is one of those upside-down paintings.

1995

24in x 30in (61cm x 76cm)

WAXWORK *(right)*

It may come as a surprise to many to learn that in the late 1980s I had become so stereotyped as a horror illustrator that I was asked to pose for the poster of John Carpenter's 1987 movie *Prince of Darkness*: I had to scream for two hours with a dead beetle on my tongue! During those years I painted album covers for people like Alice Cooper and book covers for people like Clive Barker, and I had fans with blue hair and fangs asking for autographs. So much for the 1980s …

This poster was for the 1988 tongue-in-cheek horror movie *Waxwork*, directed by Anthony Hickox.

1988

24in x 36in (61cm x 91cm)

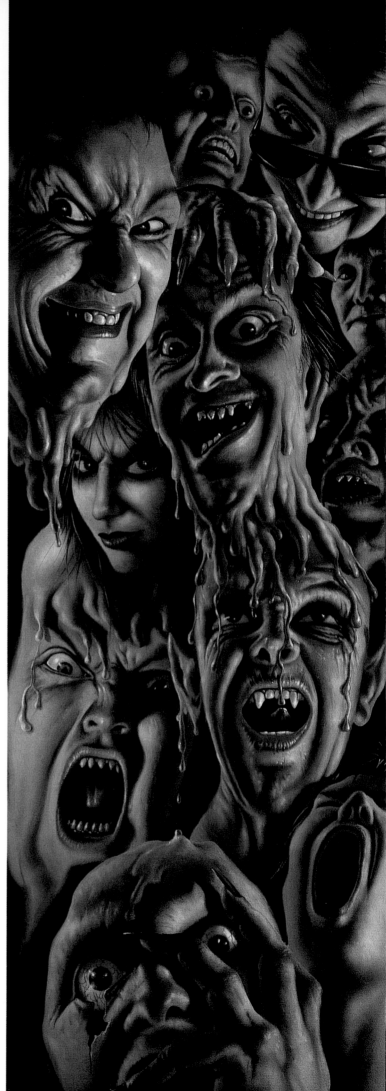

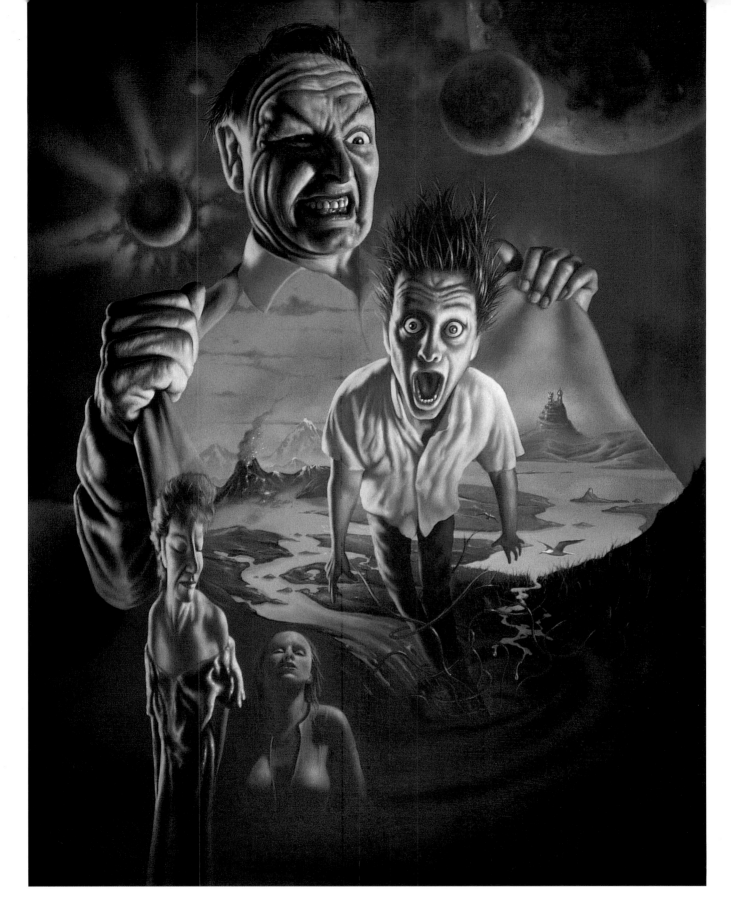

WEAVEWORLD

Myself and a couple of my relatives served as the models for this cover illustration for the 1990 Pocket Books edition of Clive Barker's horror classic. Few of the people close to me in my life haven't ended up in one or more of my paintings.

1990 24in x 36in (61cm x 91cm)

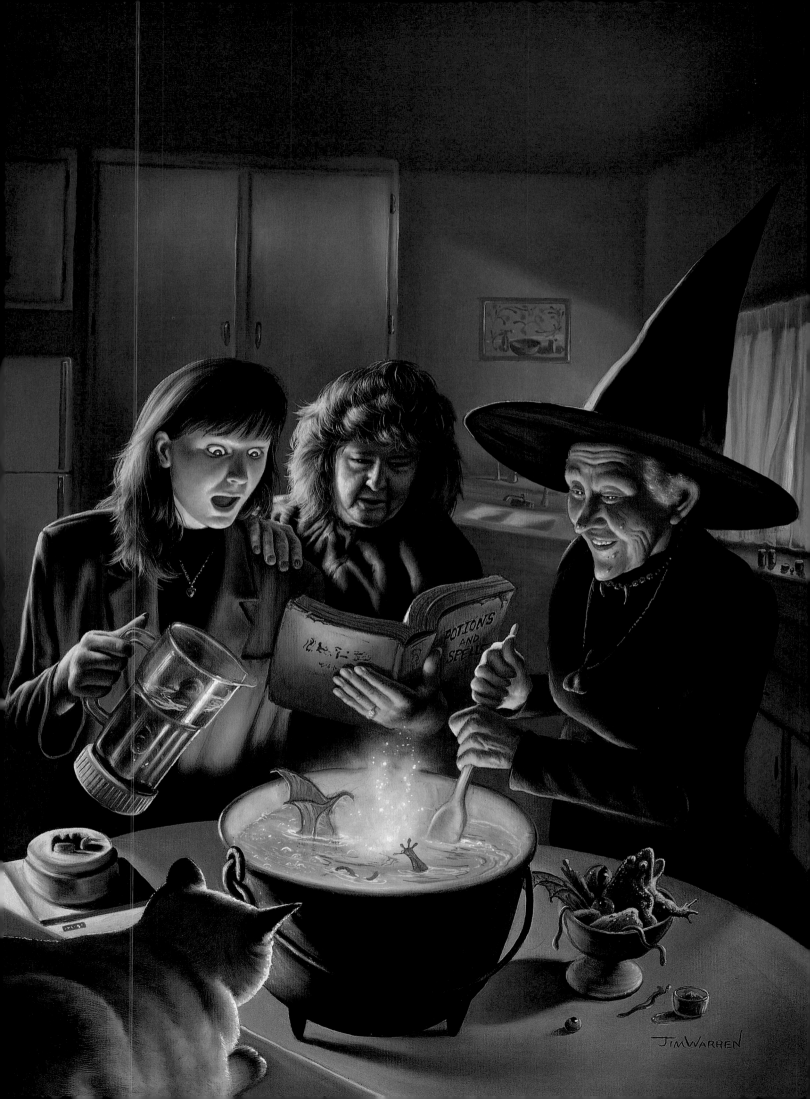

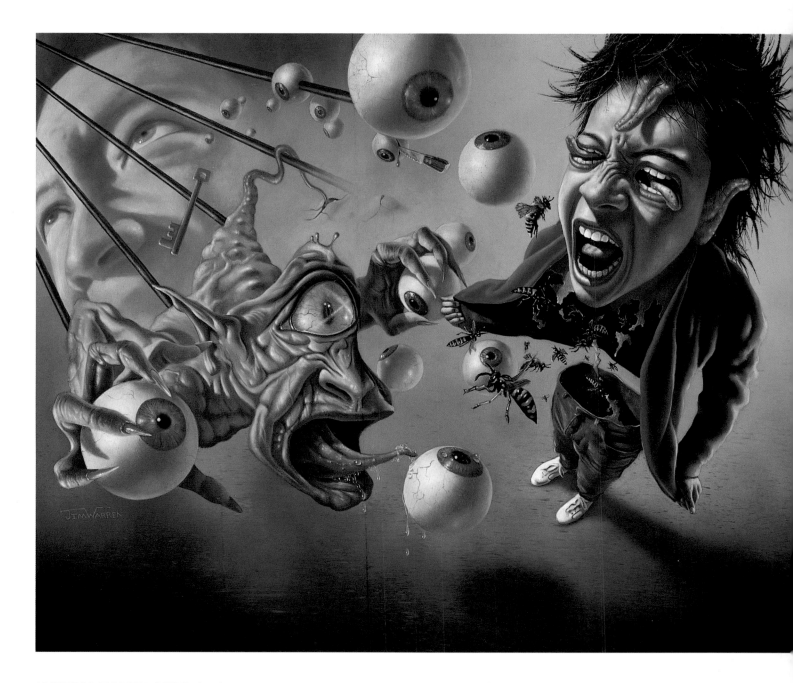

WITCH FANTASTIC *(left)*

This painting was done as the cover for a short-story anthology edited by Mike Resnick and Martin H. Greenberg and published by DAW Books. Since the stories take place in various times, from old England in the 1800s to the present, the cover brief asked me to show three generations of witches. Notice the younger, more modern witch mixing the magic brew with her blender! For visual accuracy, I used as models relatives of mine who actually are of three generations.

1990

24in x 30in (61cm x 76cm)

IN THE FLESH

I painted this for the 1986 Pocket Books edition of the story collection *In the Flesh* by Clive Barker, whose writing I consider to be a sort of surreal version of Stephen King's. Clive once said about me: 'Jim is wonderfully specific in his details. He has painted some of my favourite nightmares.'

1986

20in x 30in (51cm x 76cm)

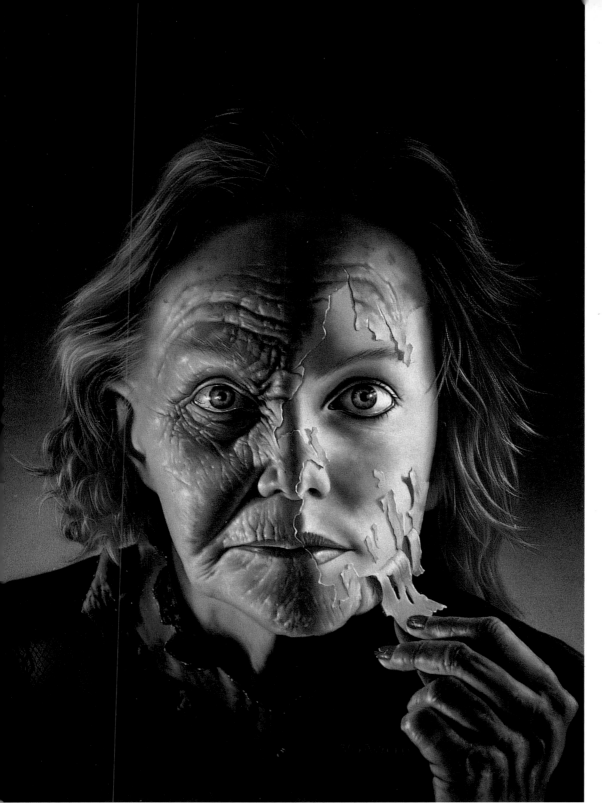

INSIDE AND OUT

(right)

I've always been a great admirer of Juliette Lewis, both as an actress and as a person. Before we did the photo shoot for this portrait I had all kinds of clever ideas for the ways in which I could produce an interpretative portrayal, but in the end I threw those out and aimed just to capture her simple, unaffected beauty. During photo shoots it's important to catch people looking completely natural and not paying any attention at all to me. This can often be very difficult, because people can be self-conscious when faced by the camera. Not Juliette Lewis: she was as easy and natural as could be.

1997

24in x 30in (61cm x 76cm)

Portrait done for

Juliette Lewis

TURN BACK THE CLOCK

This was done in the 1980s as the cover illustration for a book whose title I no longer recall because of the sheer number of covers I was illustrating at the time. For one half of this picture I used as a model my wife's 82-year-old grandmother.

1986

24in x 30in (61cm x 76cm)

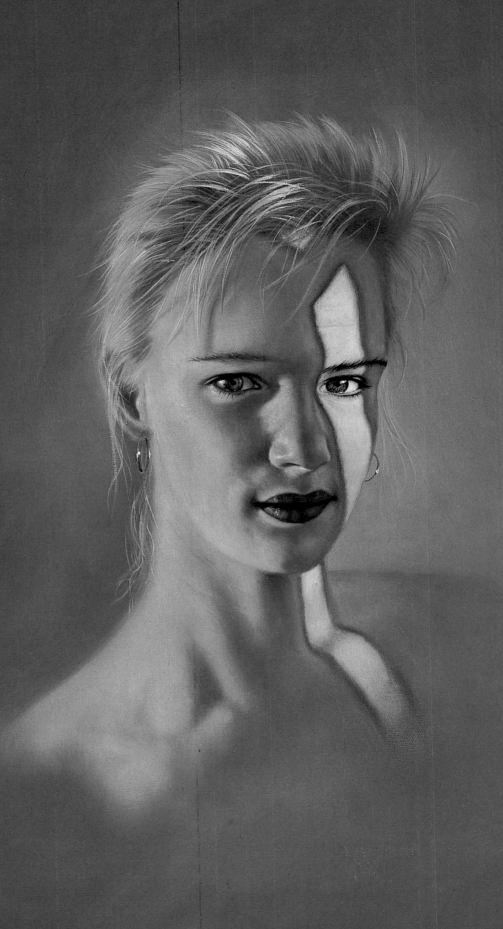

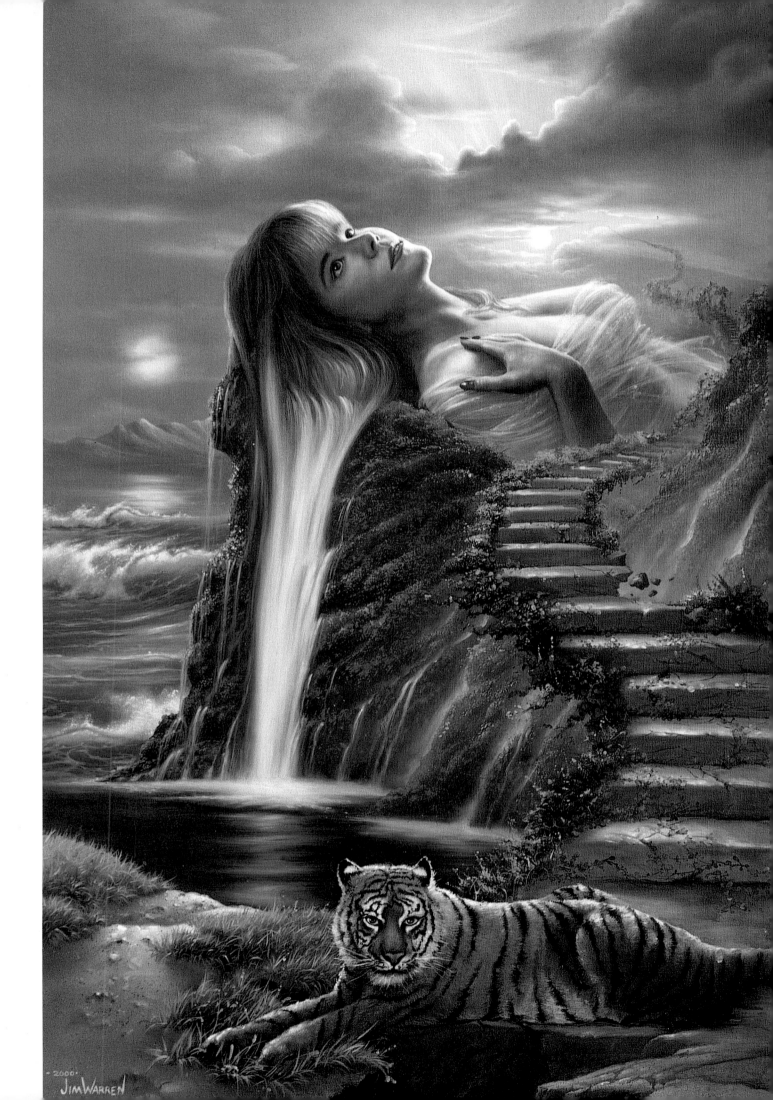

PORTRAIT FOR JENNY *(left)*

When I photograph a person for a painting I have not just to capture their true essence on film but to visualize the painted settings I will be putting them in. Getting to know them as people is another very important part of the whole portrait process. Jenny wanted me to paint her in a scene that was very personal to her. The request was for something spiritual, sensual and symbolic, and that she should have her favourite animal, a tiger, lying in front of the steps as if to guard her private world.

2000

24in x 36in (61cm x 91cm)

Portrait done for Jennifer Dowling

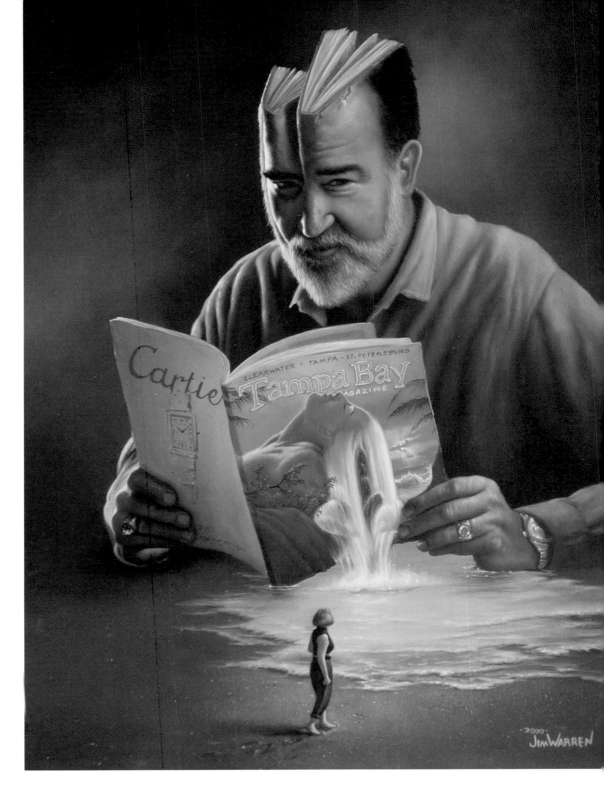

PORTRAIT OF AARON FODIMAN

Aaron is the editor and publisher of the prestigious *Tampa Bay Magazine*. For his portrait we decided to have him reading his own magazine, and in fact the issue which had my painting *Island Dreams* on the cover. The 'book-head' theme which I've used several times in the past (see page 85, for example) represents the idea that 'you are what you read'.

2000

20in x 30in (51cm x 71cm)

Portrait done for Aaron Fodiman

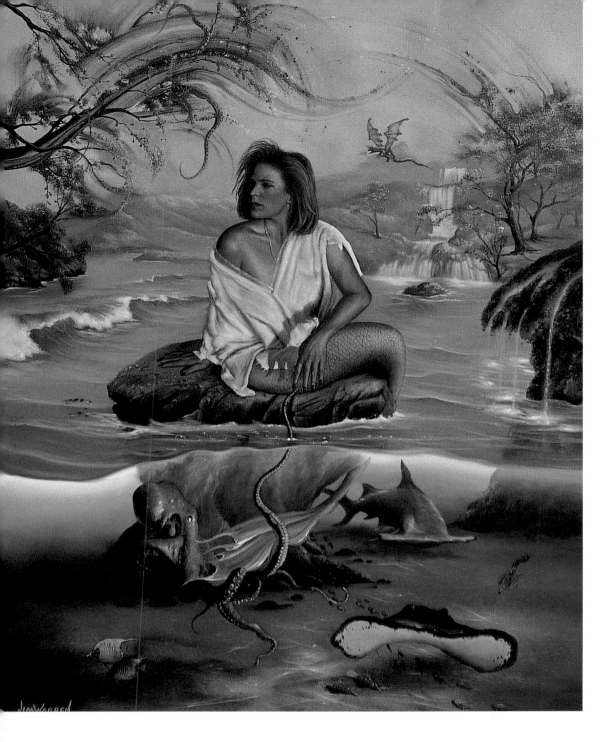

PLACE OF OUR OWN

A portrait of Mari, who designed much of my website (www.jimwarren.com). I deliberately mixed the serene with the threatening to make a unique painted world for her. I think the most fun and challenging part of doing a portrait consists of the discussions between me and the client as to the concept to be painted.

1999

24in x 30in (61cm x 76cm)

Portrait done for Mari Griffin

MARCIA TYSELLING PORTRAIT *(right)*

I actually call my portraits 'personalized paintings' rather than portraits, as my aim is to make them pretty much stand on their own as pieces of art – they should be interesting not just to the people who have commissioned them or are their subjects. Marcia and I decided on a painting that was peaceful and natural and that featured her pet dog and her macaw, along with a few other animals thrown in for effect.

1996

24in x 30in (61cm x 76cm)

Portrait done for John Tysellng

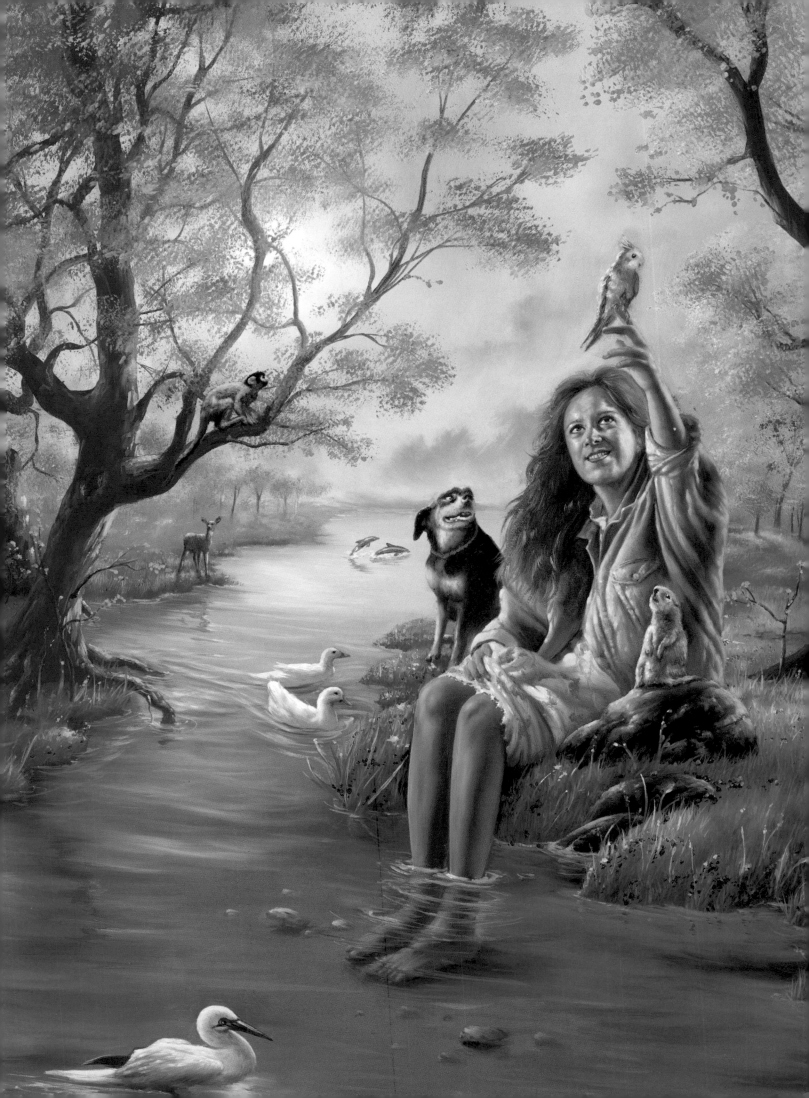

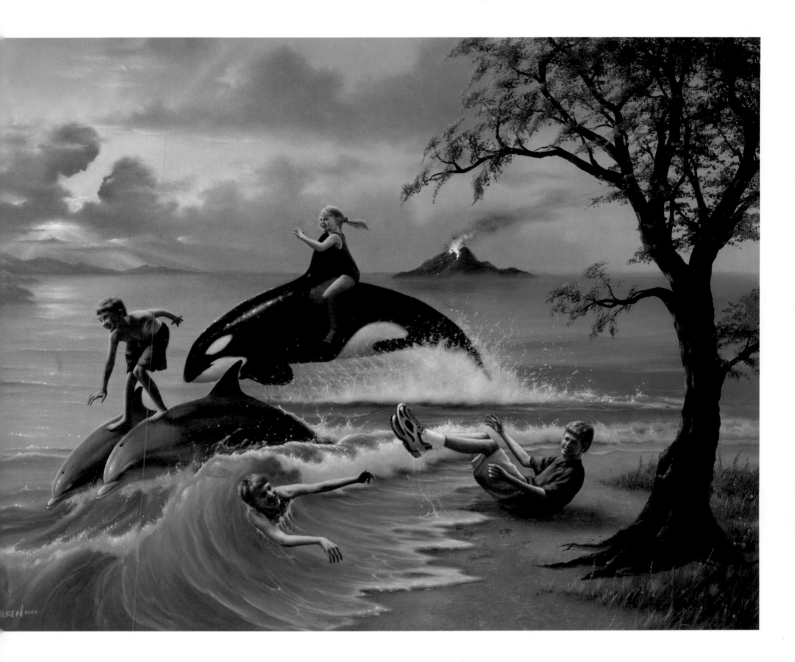

PORTRAIT OF THE GARBUS FAMILY

It had never really crossed my mind that I should get into portraiture. What happened was that people who viewed my paintings in galleries would often discover that the models I'd used were my relatives or friends – and, in particular, my children. It seemed logical to those viewers that, if I could paint my own children, I could paint other people's – and so the commissions started coming.

2000

30in x 40in (76cm x 102cm)

ELEVEN GRANDCHILDREN

This is the most people I've ever put in a single portrait painting. I photographed them in groups of two to four. Later, while doing the painting, I mixed and matched the best of the faces, hands and so on with the bodies. I felt like Victor Frankenstein!

1998

30in x 40in (76cm x 102cm)

Group portrait done for John and Betty Maliszewisky

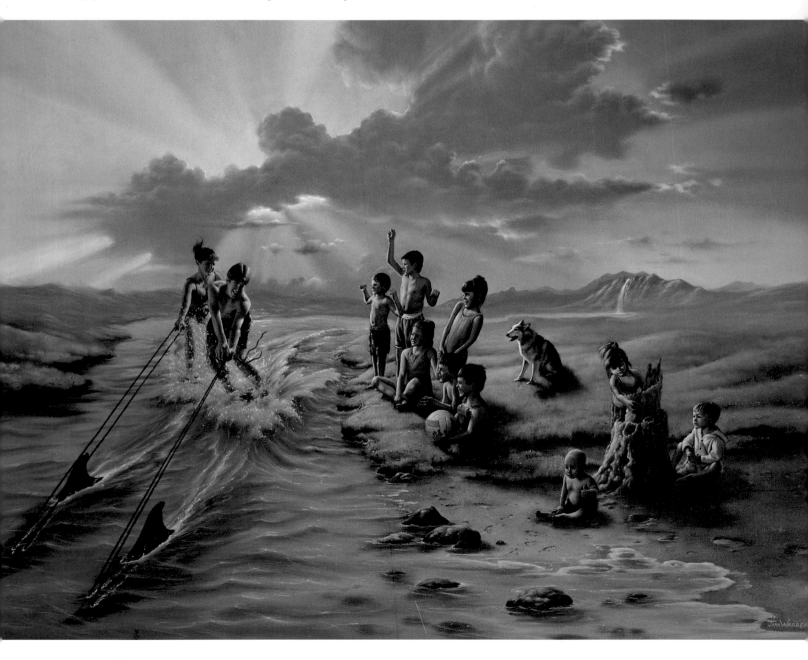

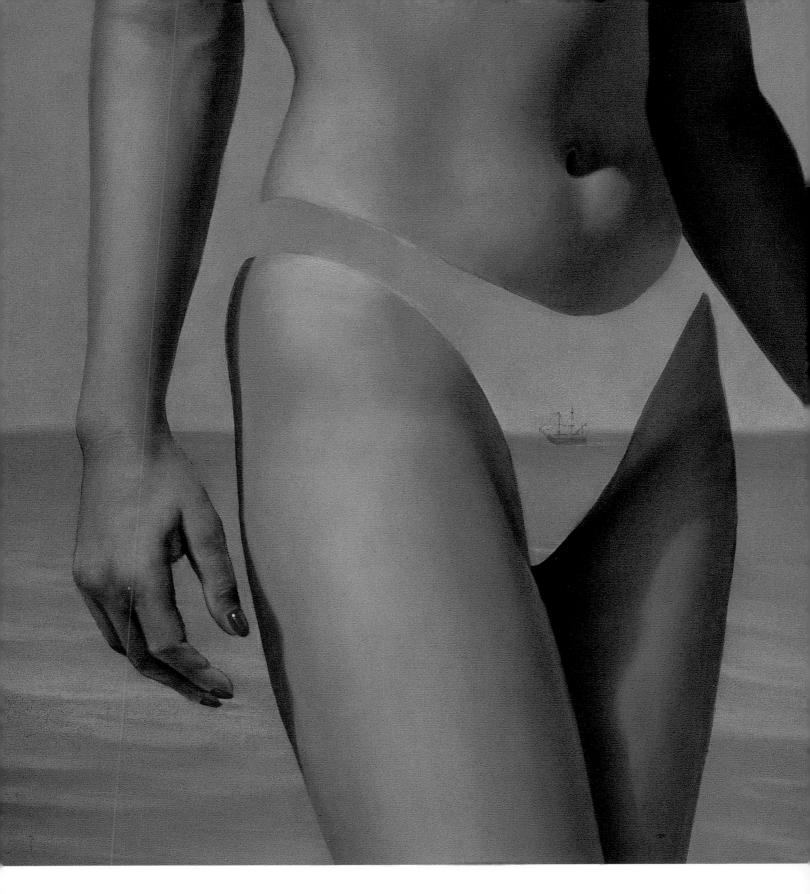

GIRL WITH THE SEA-THRU BIKINI

I got this idea on the beach when I saw a girl in a bikini standing in front of the water. Luckily I had my camera with me to take some reference pictures. I sometimes wonder, when people notice me shooting a stranger candidly, if they think I'm a pervert, a reporter or a private investigator. Maybe I need a big hat that reads: 'I'm just an artist!'

1995 24in x 30in (61cm x 76cm)

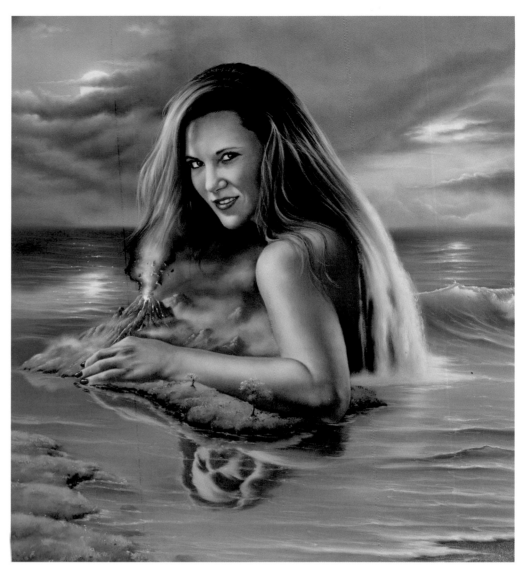

A WORLD OF HOPE

Portraits are really collaborations between the subject and myself: although I do the actual painting, we generate many of the ideas between us. Sometimes I plan ahead with sketches before the photo shoot and other times the ideas come spontaneously during the shoot, or sometimes even not until after I've seen the photographs. For this one I laid a mirror down on the table underneath Hope while she posed with this great expression that I can only describe as 'sultry'. She said about this painting: 'I've been a fan of yours since I was a kid. You not only painted a photo-quality portrait of me, but you discovered in two short meetings the two sides of Hope.'

1999

24in x 30in (61cm x 76cm)

Portrait done for Hope Andrews

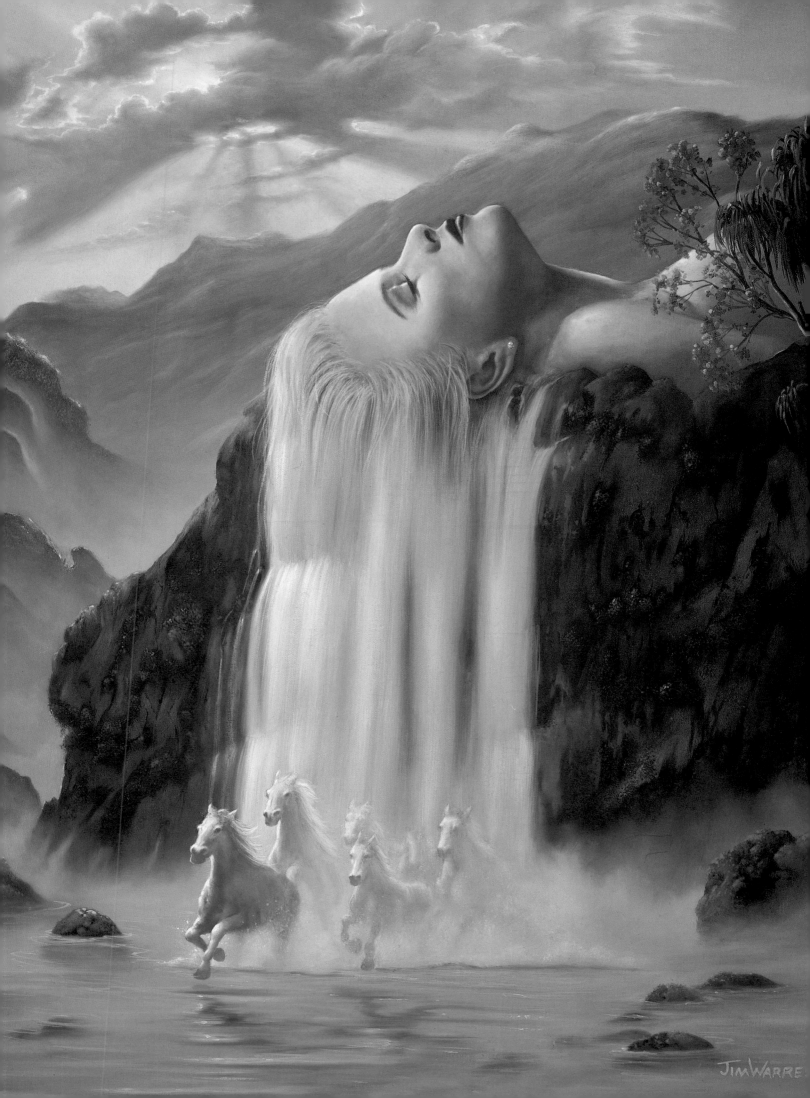

DAYDREAMS *(left)*

My philosophy in art has always been: 'To heck with the rules – paint what you like.' This is an example of my mixing the mundane with the exotic to convey not just a sense of surrealism but also a whole mood.

1998

24in x 30in (61cm x 76cm)

SEA OF LOVE

The way people view their environment very much reflects the emotions they feel at the time. The same could often be said about the way I paint. This painting is about the way the world appears to people who are in love.

1991

24in x 30in (61cm x 76cm)

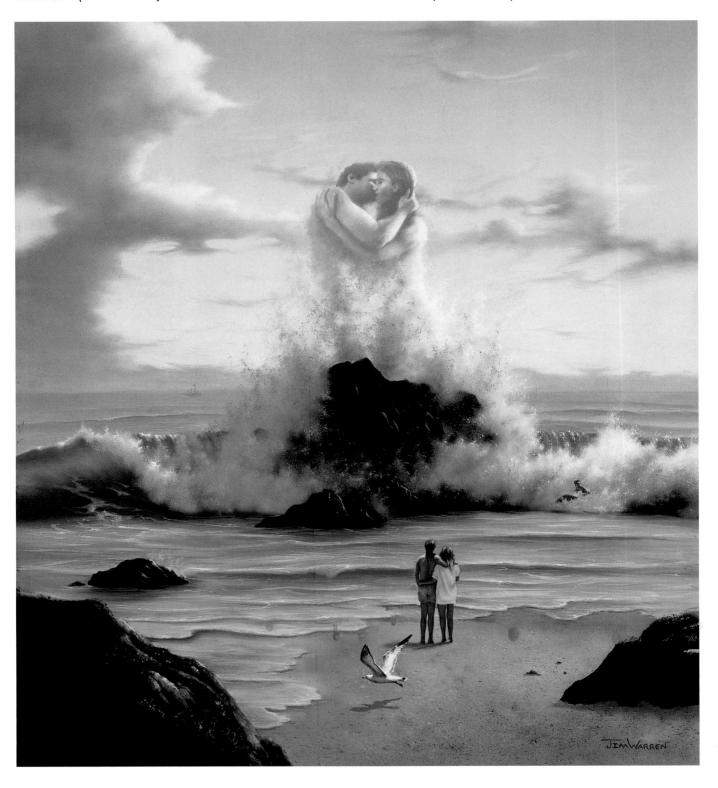

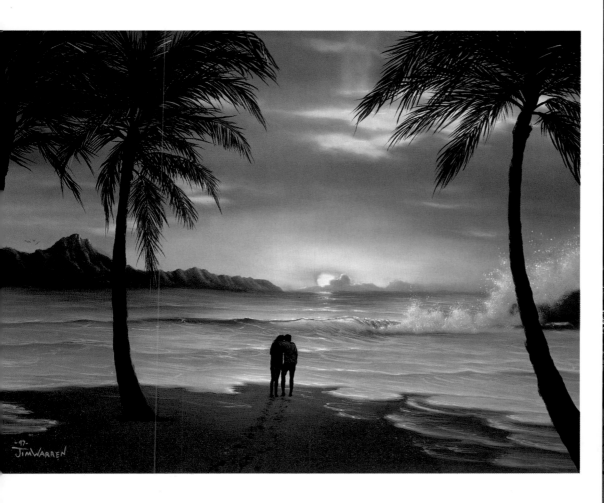

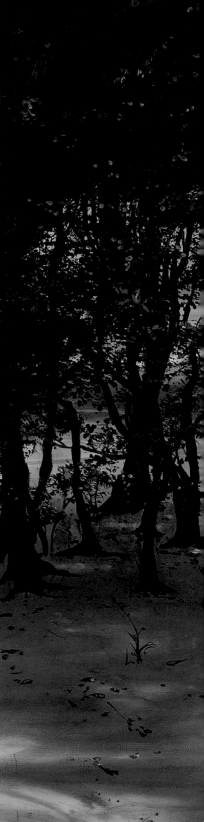

ROMANTIC SUNSET

One day, while driving by a beach near my home in Clearwater, Florida, I spotted the most strikingly romantic sunset. We have no mountains in Florida, nor crashing waves like the ones I have painted here, but my view from the car window did include the couple standing by the water and the two palm trees. I knew at that moment what my next painting was going to be.

1997

20in x 30in (51cm x 76cm)

Published as greeting cards and limited-edition prints

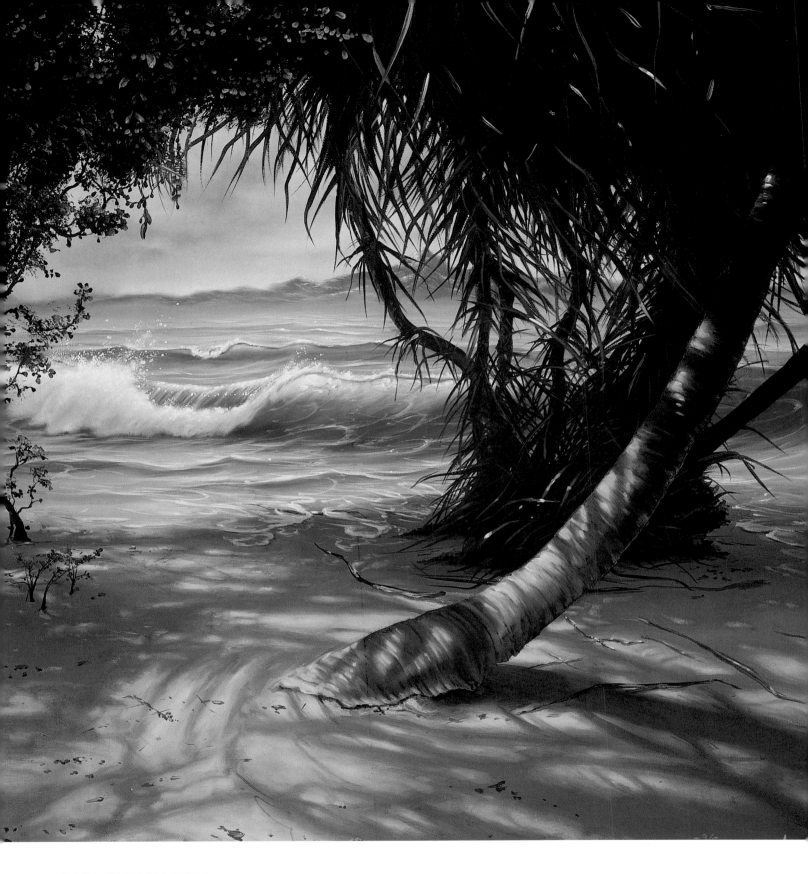

CARIBBEAN VIEW

The view in this painting is made up of a mixture of the Florida Keys and Hawaii. I never paint a totally real place: usually take items of scenery from various different locations and combine them.

1997

20in x 24in (51cm x 61cm)

Available as limited-edition prints

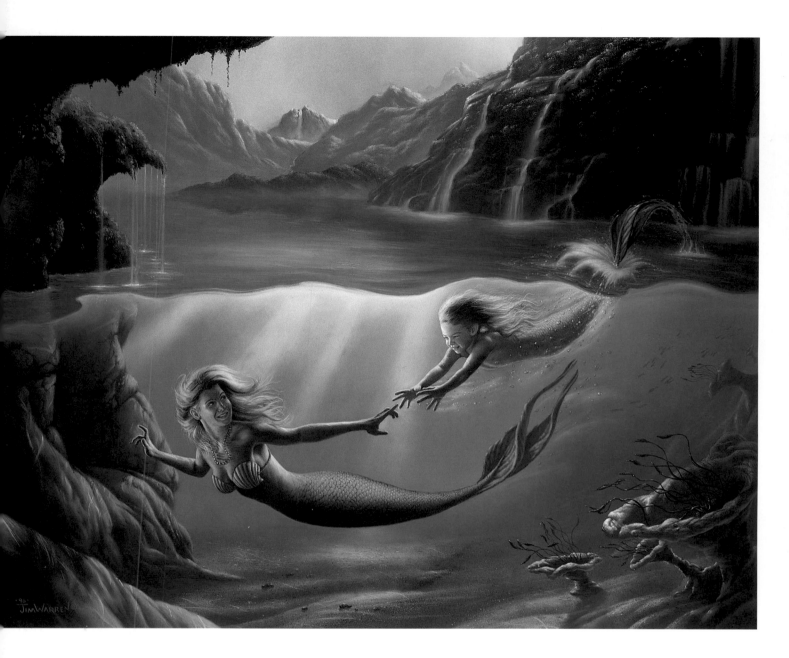

MOTHER & CHILD

I got the idea for this painting when I came across the people who eventually became the models for it. It was just a chance encounter on a plane when I was going home after a show.

I think watching people is more entertaining than watching most movies. Malls and beaches are great places to watch people, as they are most themselves there.

1996

30in x 40in (76cm x 102cm)

TIGER WITHIN (right)

I confess that I did this painting simply because I thought it would make for an interesting visual effect. Most of the women who've talked about it with me, though, say that it means something much more than that to them – that it represents the true woman inside breaking out from behind the 'meek girlie' persona that the world tends to thrust upon them. Now that I think about it, maybe that was what I intended all along …

1991

24in x 30in (61cm x 76cm)

Available as limited-edition prints

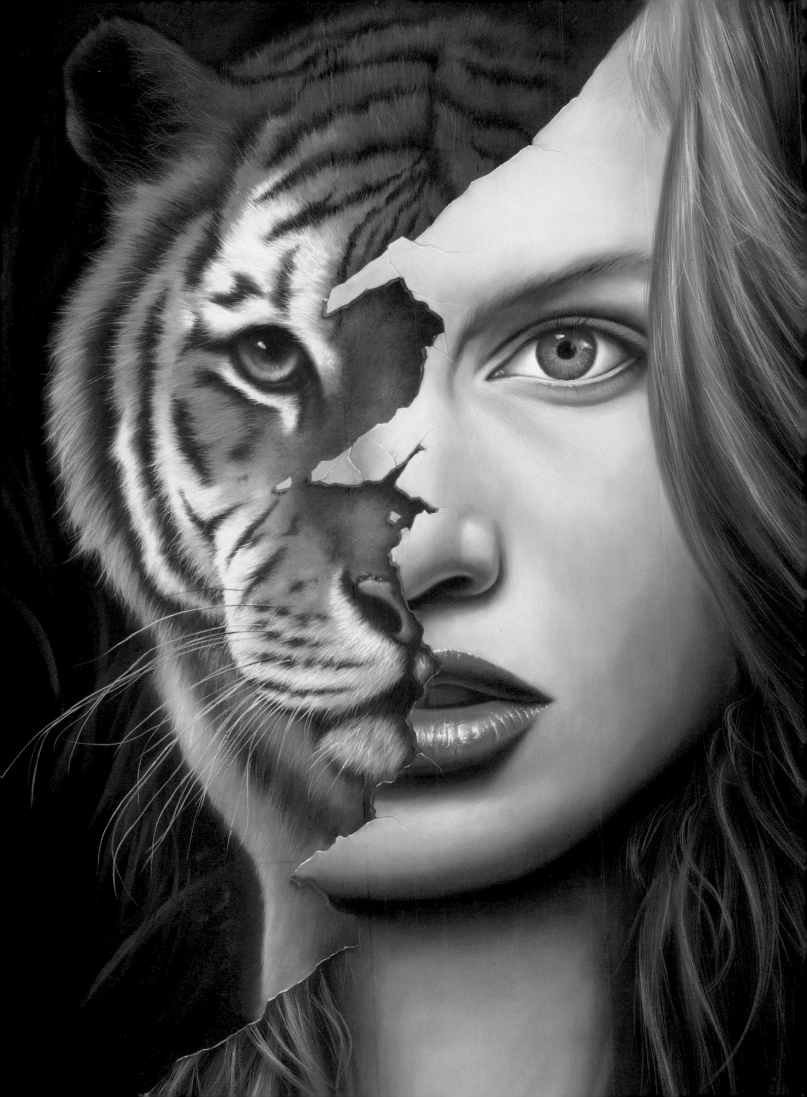

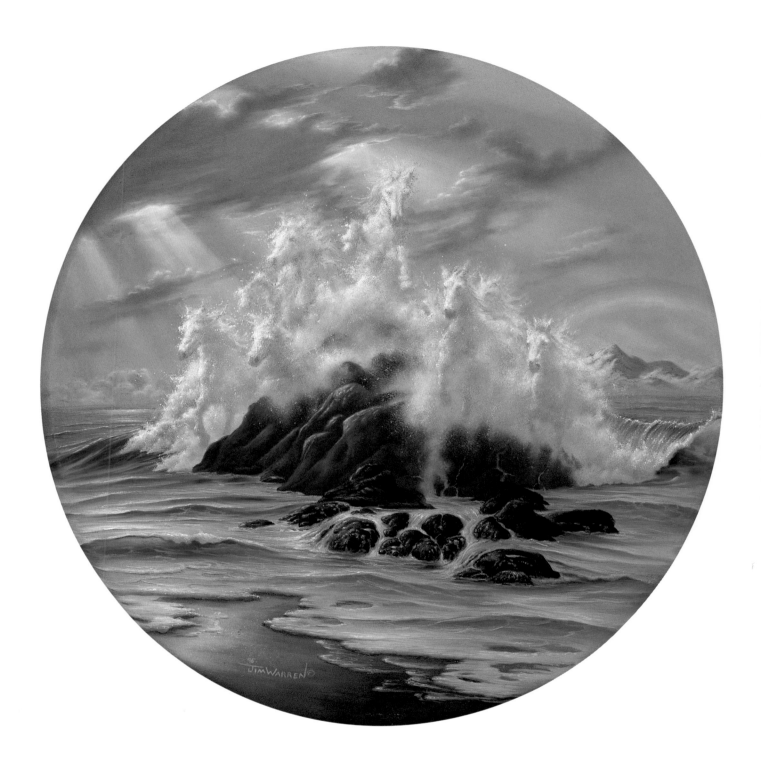

RESTLESS SEA

My art is constantly growing and changing but
some of my themes – such as horses and the
sea – constantly recur.

1995

30in (76cm) diameter

Available as greetings cards, limited-edition prints

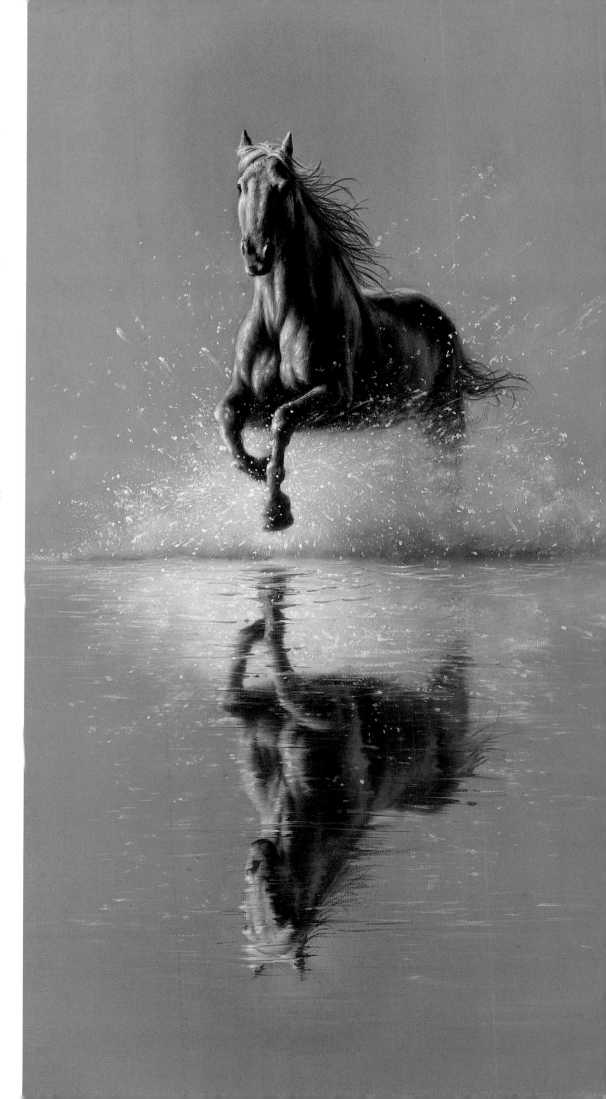

RUNNING WITH THE WIND

In 1980 I did the cover for the album *Against the Wind* by Bob Seger and the Silver Bullet Band, showing five horses running through shallow water, with their reflections beneath them. I heard on the grapevine that some people were buying the album just for the cover, so they could hang it on their wall. It really brought home to me how popular horses are in art, and as I love painting horses anyway …

This painting is a variant of *Against the Wind*, which you can see on page 11.

1996

16in x 20in (41cm x 51cm)

Available as greetings cards, limited-edition prints

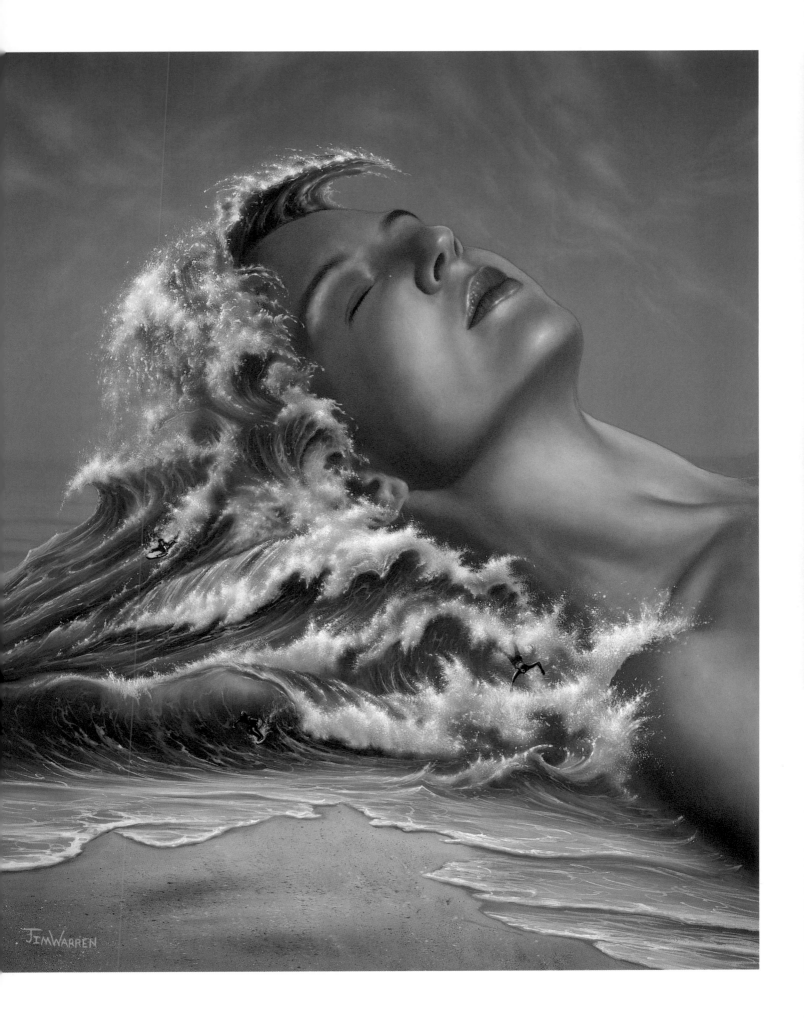

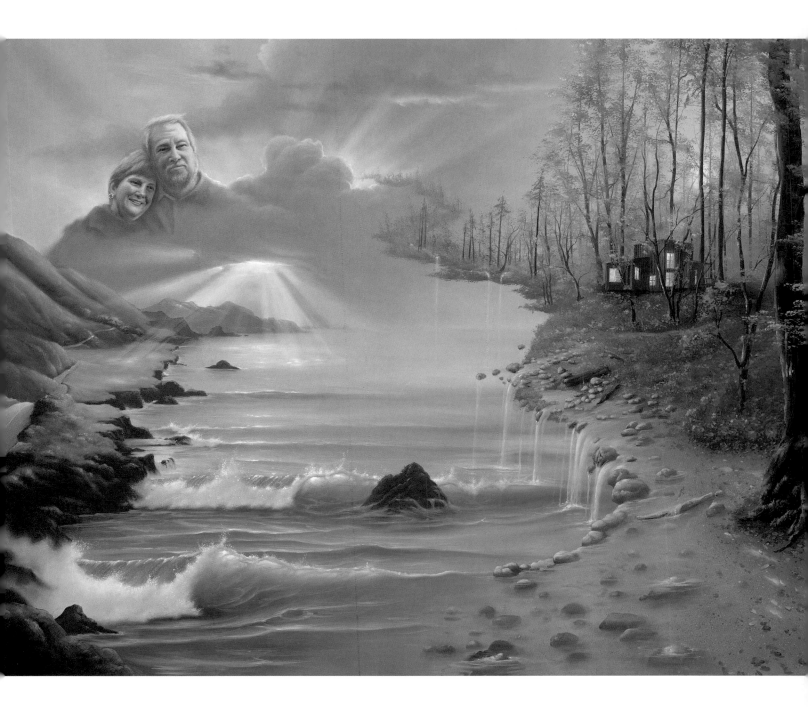

GIRL WITH WAVY HAIR *(left)*

Sometimes my paintings are inspired by word-plays, like this one. If it weren't for the title, people might not understand why I did the painting.

1993

24in x 30in (61cm x 76cm)

OUR HOUSE

This painting is set in Big Sur, California, famous for its beautiful oceans, redwood trees and winding roads. As no one scene can truly represent the area as a whole, I photographed many locations and blended them together to make this surreal portrait.

2000

30in x 40in (76cm x 102cm)

Portrait done for Richard and Sally Taylor

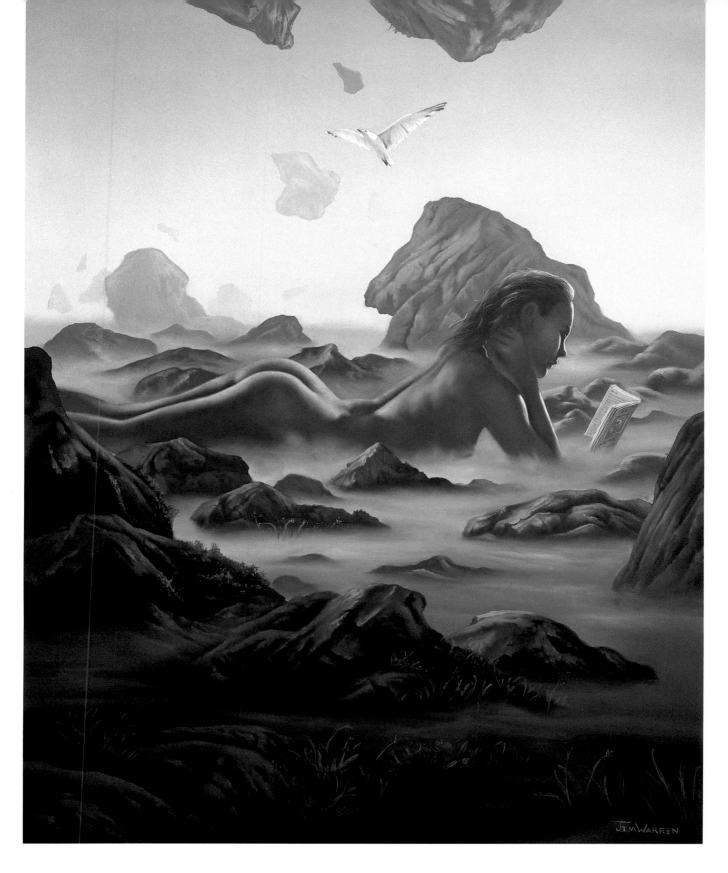

WITHIN THE PAGES

A good book, like movies and music, should make
you feel as if you are in another world.

1985

24in x 30in (61cm x 76cm)

Available as limited-edition prints

HOUSE WITH A VIEW

A lot of my ideas concern things I would like to see or experience myself but which are, to a greater or lesser degree, beyond what I am in fact able to see or experience. This is precisely why I feel the need to paint them. The house in this picture is to me the perfect place for those who really want privacy and a great view.

1993

24in x 30in (61cm x 76cm)

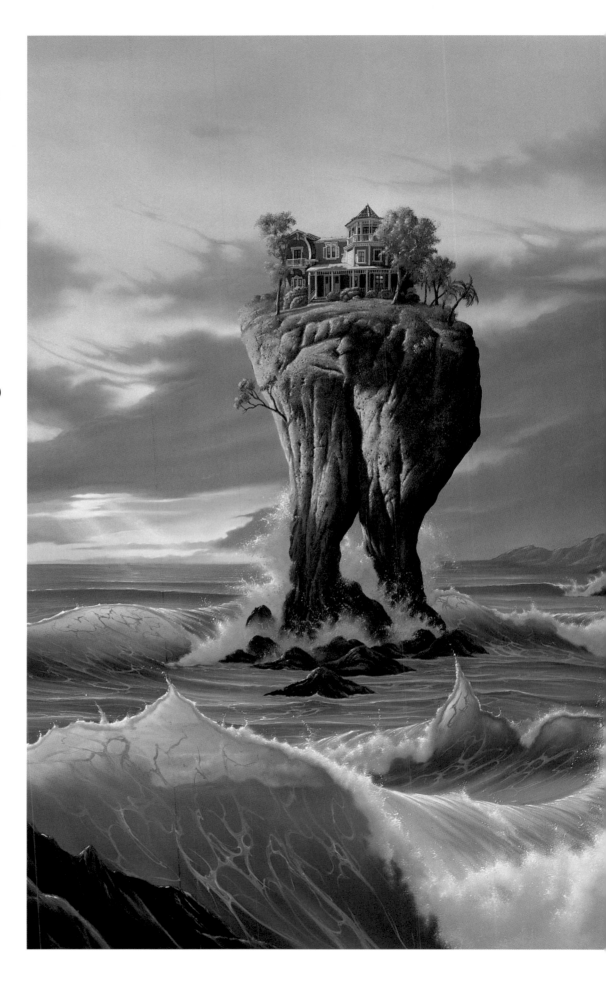

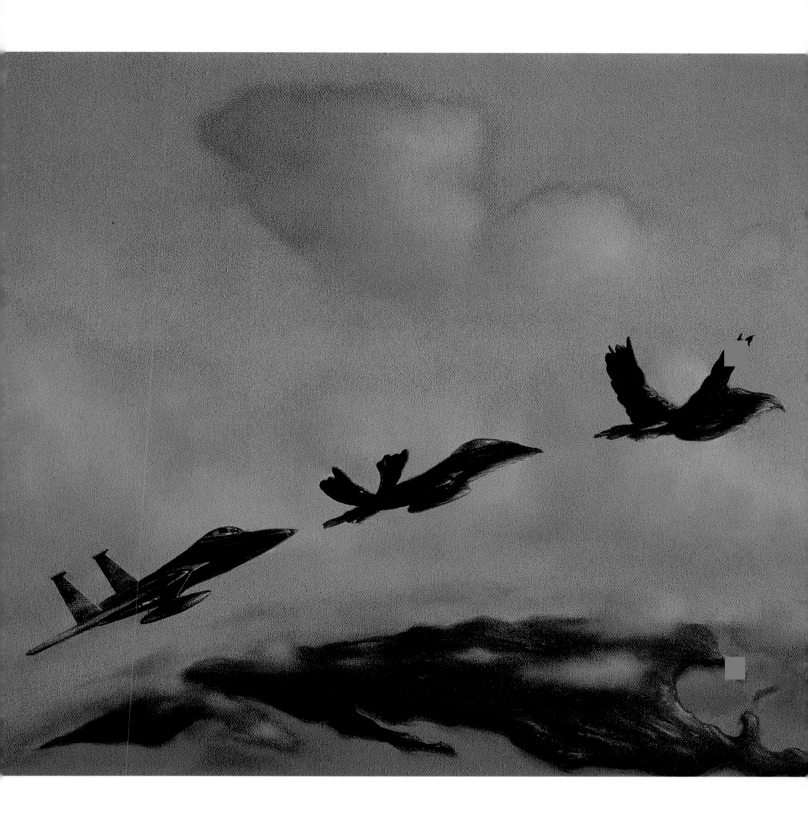

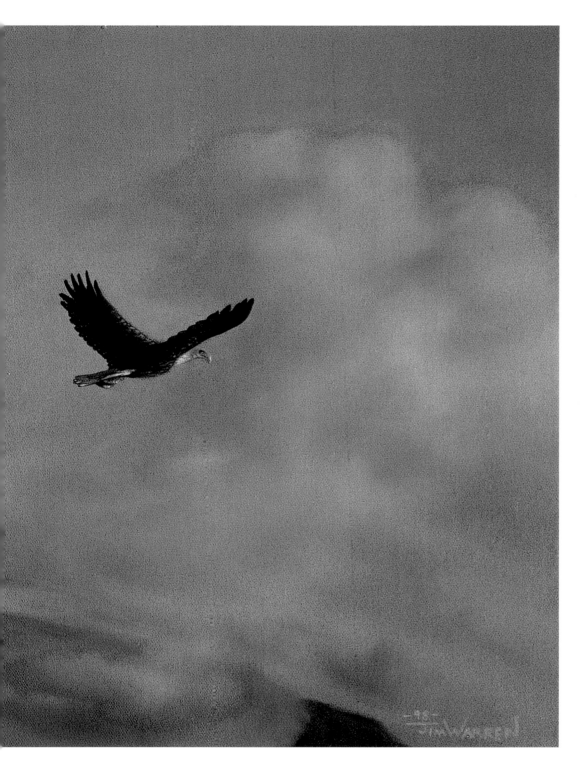

METAMORPHOSIS

As the threat of global war has diminished, what once was a symbol of war has been transformed into a symbol of peace.

1997

15in x 30in (38cm x 76cm)

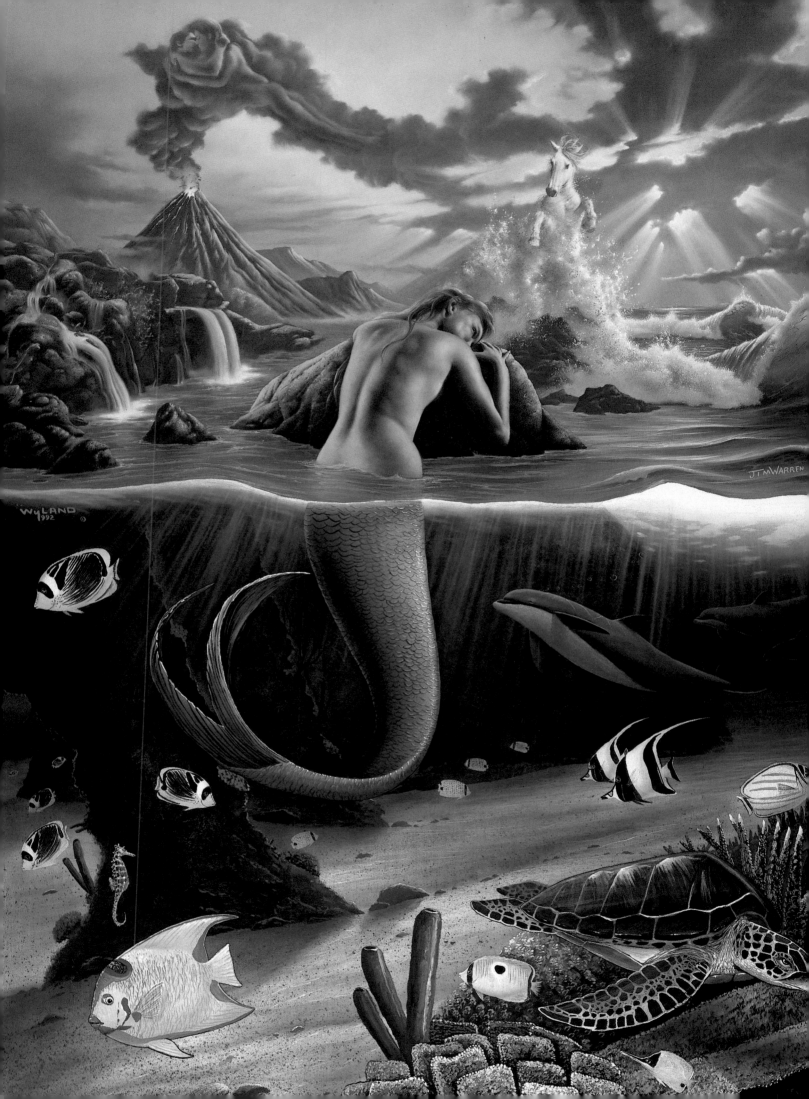

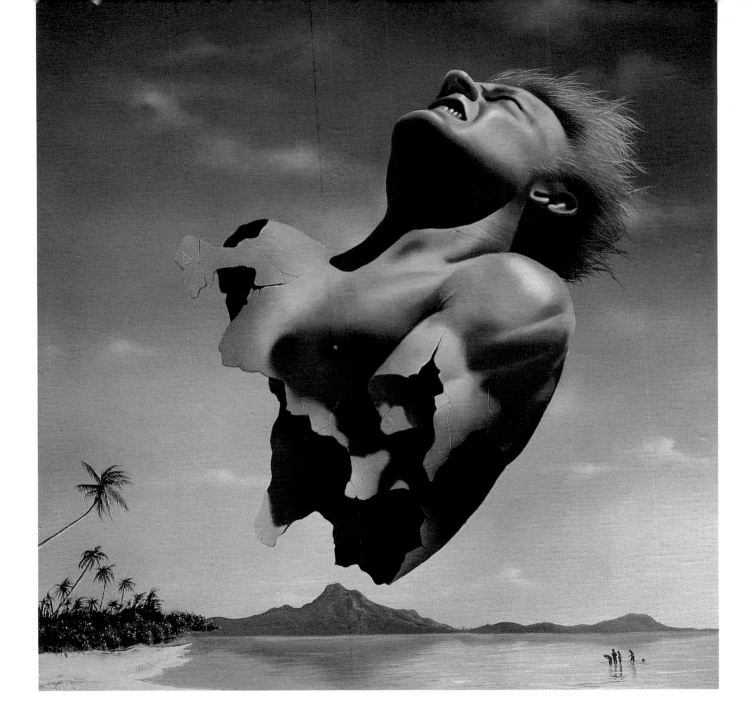

MERMAID'S DREAM *(left)*

This was the first painting Wyland and I did together – I did the top and he did the bottom. The idea concerned a lonely mermaid who, although she lived in the beautiful undersea world of dolphins and fish, dreamed of doing the things that only humans can do. I was going to call it *The Lonely Mermaid*, but in the end we decided not to emphasize the sadness of it too much. The model was my stepdaughter Rebecca.

1992

36in x 48in (91cm x 122cm)

Available as limited-edition prints, posters, T-shirts, various other gift products

UNKNOWN SOLDIER

I think I have a great knack for taking a depressing subject and making it appear interesting as a piece of art. Maybe that's because I really try not to take anything all that seriously.

1983

22in x 28in (56cm x 71cm)

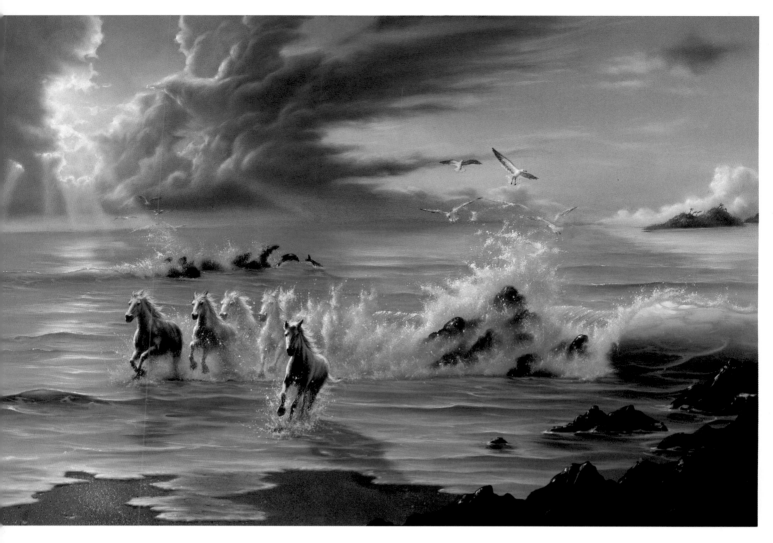

LIVING SEA (above)

Some say God created living things and some say life
simply evolved from the sea. I don't claim to be an expert,
but I think most living things are far too beautiful to have
been just an accident.

1998

24in x 36in (61cm x 91cm)

MR FISH (right)

This picture was probably influenced by the work of
the Surrealist painter Renè Magritte, who could make
you think without having any point in particular. Mr Fish is
just … well, Mr Fish.

1979

22in x 28in (56cm x 71cm)

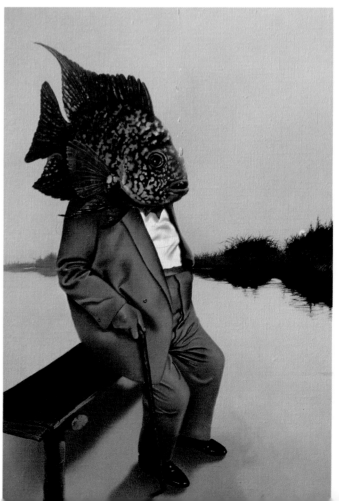

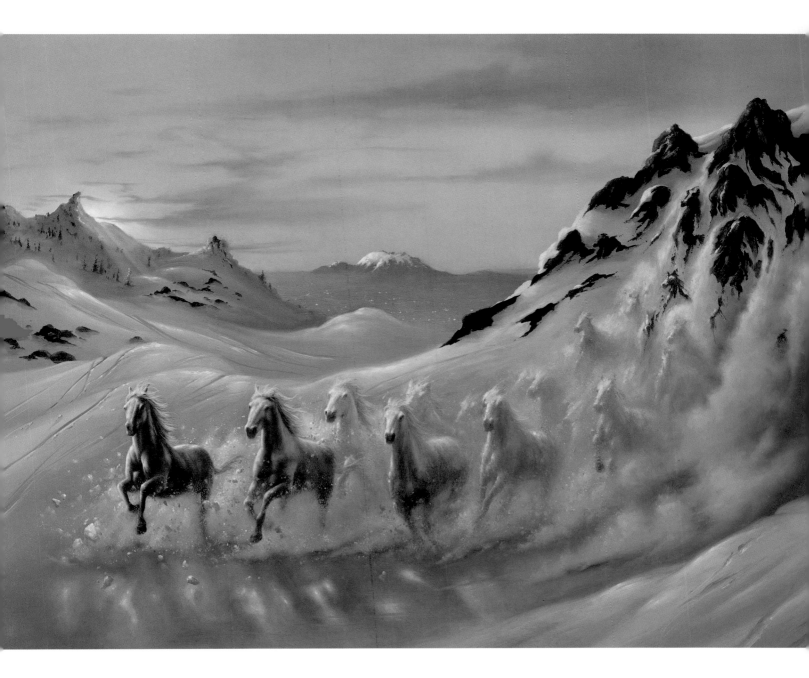

AVALANCHE

This was the last painting that was completed before going to press with this book. It occurred to me that I had been painting oceans in almost every painting in recent years and it was time for a little cclc winter snow. I may also have been influenced by the fact that the Christmas Season was right around the corner.

2000

24in x 36in (61cm x 91cm)

Published as limited-edition prints

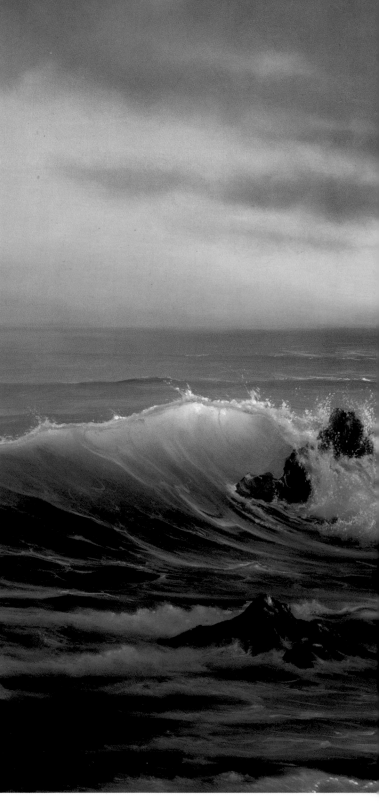

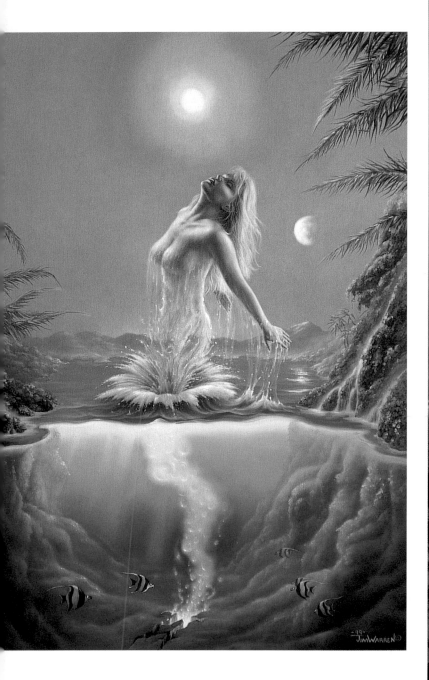

FOUNTAIN OF YOUTH

I painted this for Dr Randall Harrell MD, who used it in his advertisements for anti-ageing plastic surgery. I jokingly suggested he should use the painting *Turn Back the Clock* (see page 30) …

1999

24in x 36in (61cm x 91cm)

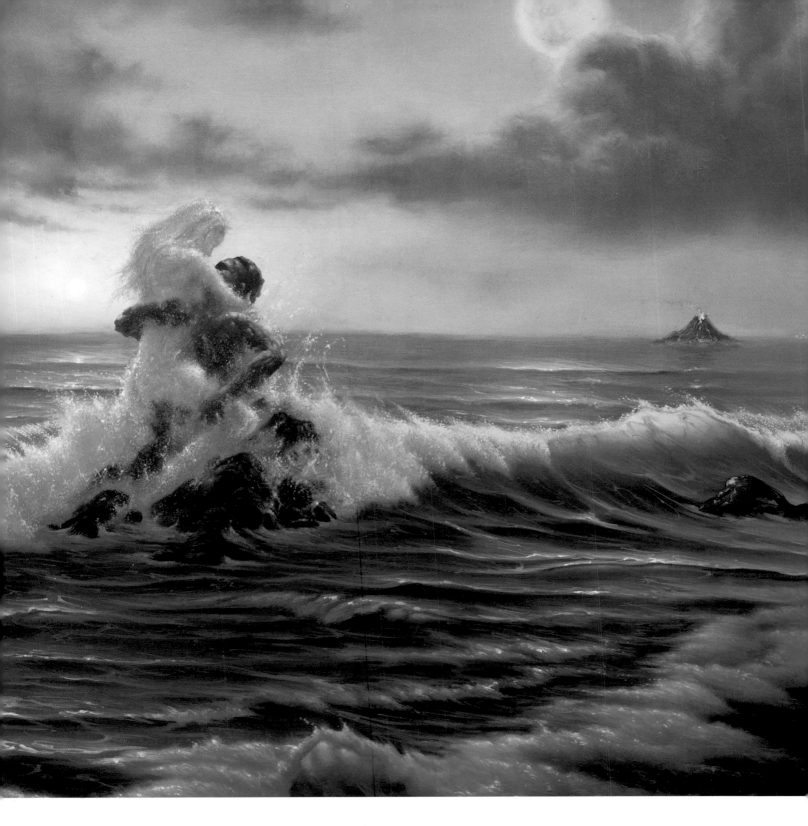

AT SUNSET

This painting is of one of my trademark themes, romance, with a warm romantic sunset to set the mood.

At Sunset and many of my other paintings are now being reproduced as limited editions on canvas by a process known as giclèe (pronounced gee-clay). This process, more than any other in the past, has captured amazingly the subtle colour blends and details that I strive so hard to achieve. Because the number of originals I can produce is obviously limited, it's pleasing that through this process a broader audience is now able to view my paintings in the way that I intended them to be viewed.

1998 24in x 30in (61cm x 76cm) Available as limited-edition prints

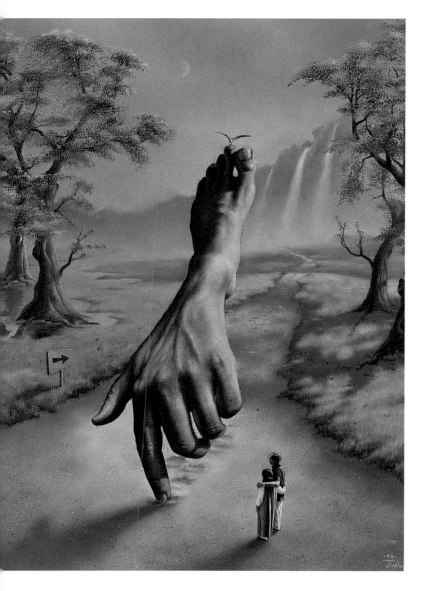

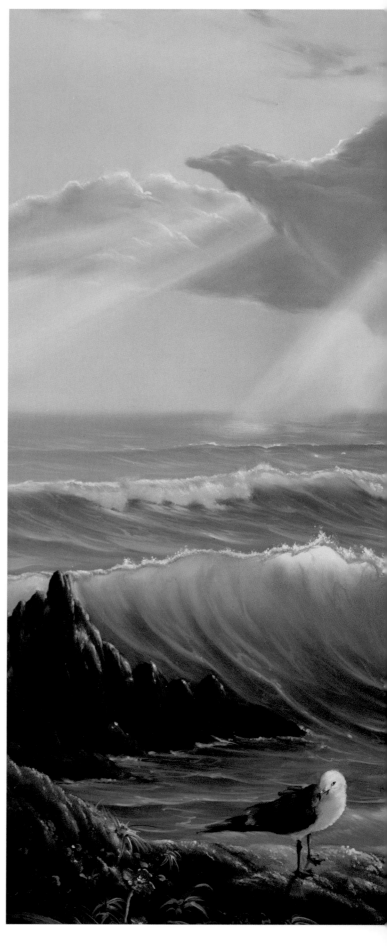

MAN WITH NO WORDS

It can be hard for people when they have a lot to say but no words with which to say it.

1999 24in x 30in (61cm x 76cm)

ENCHANTED SEA *(right)*

Working five to eight hours a day, it takes me between one and two weeks to complete a painting. But that's only the half of it: it might also take me that long to come up with an idea that I like. Furthermore, it took me over thirty years to be able to paint as quickly as I do. So, when people ask me how long a particular painting took, I reply: 'Thirty years!'

1999

24in x 30in (61cm x 76cm)

Available as greetings cards, limited-edition prints

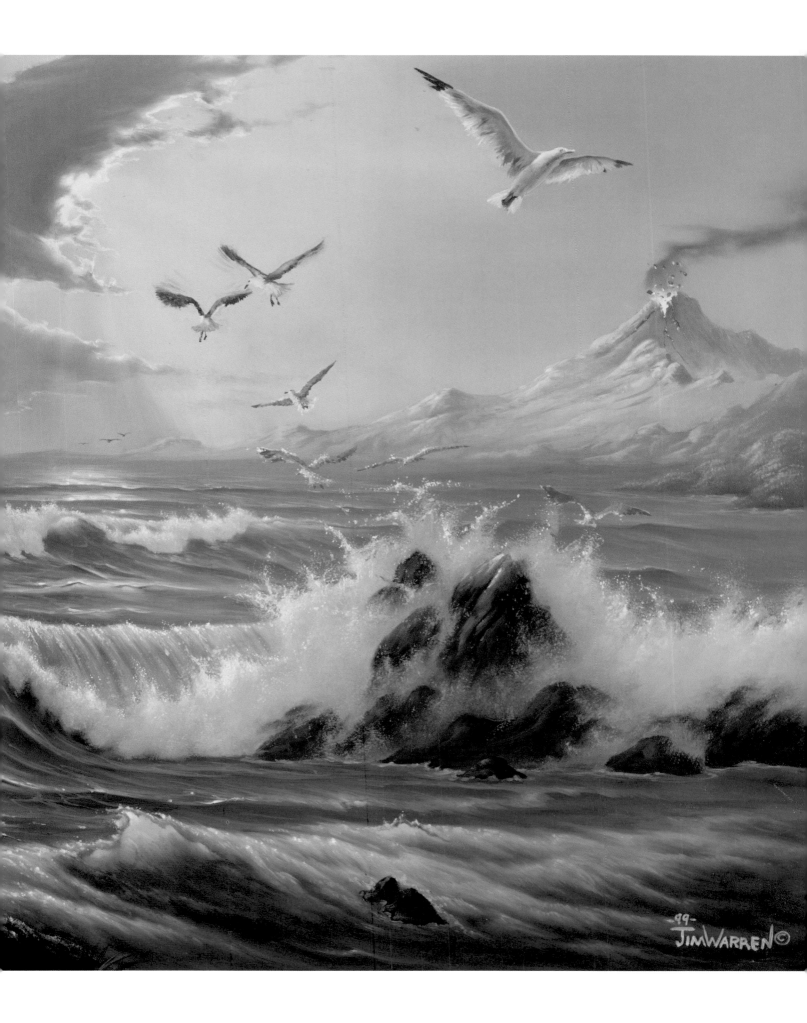

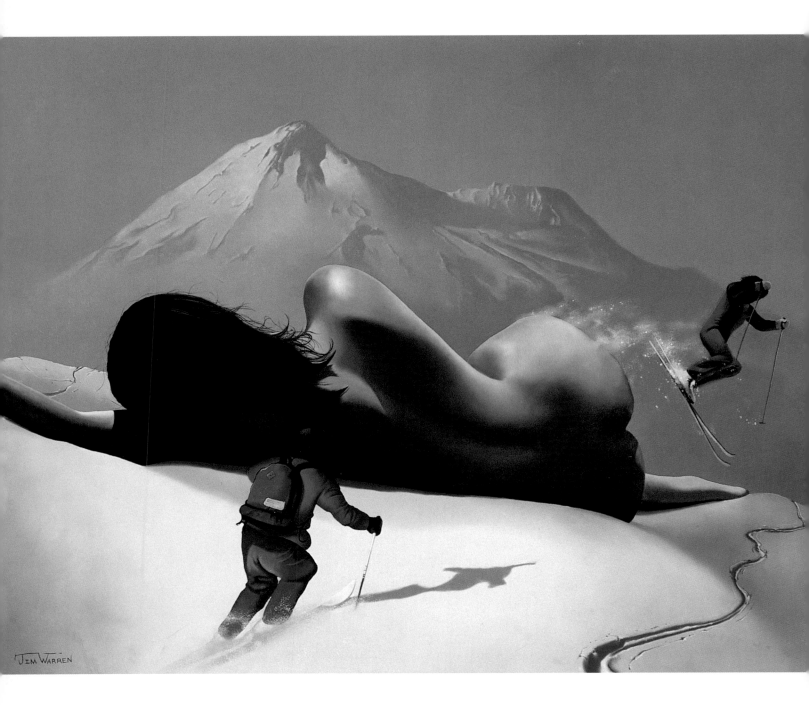

ON THE SLOPES

I now feel this is a stupid, immature male-chauvinist
painting – but it's still kinda fun.

1979
24in x 30in (61cm x 76cm)

LIVING ON THE EDGE *(right)*

People who look at a painting of mine don't all see the
same picture – they see different things that relate
specifically to them. This interaction between picture
and viewer, so that the viewer as well as the painter is
contributing to the creative experience, is to me what
art is all about.

1993
24in x 30in (61cm x 76cm)
Available as limited-edition prints

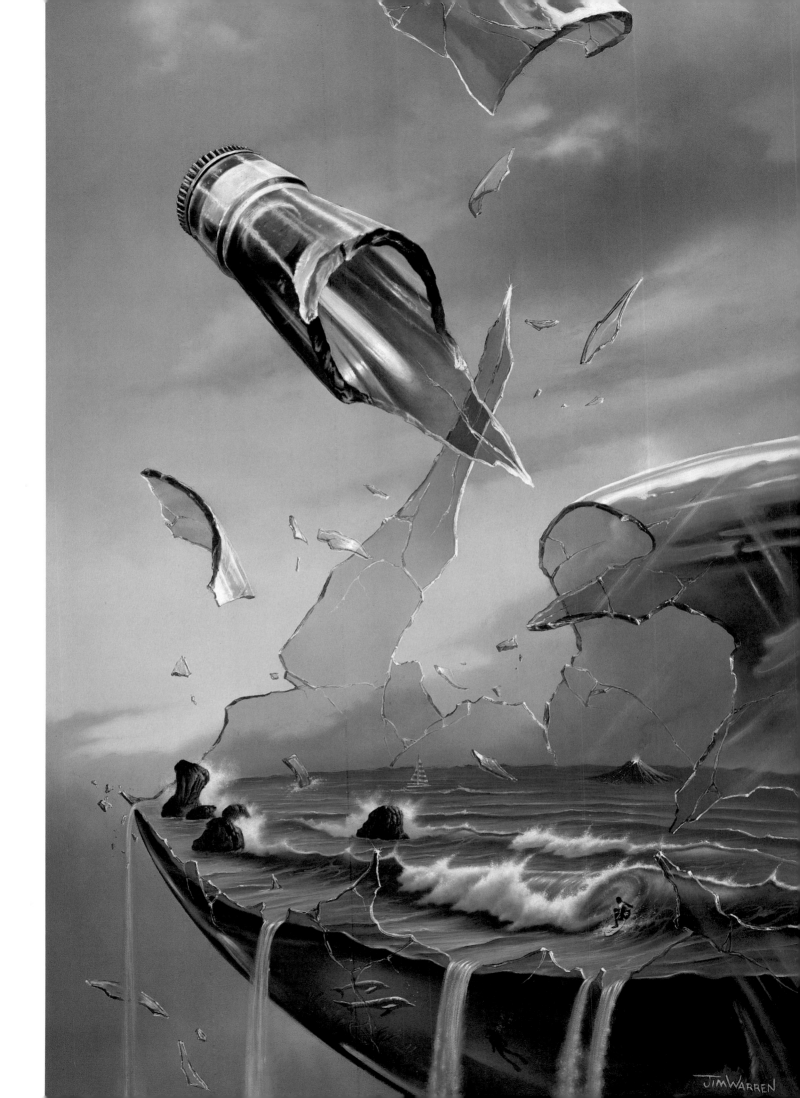

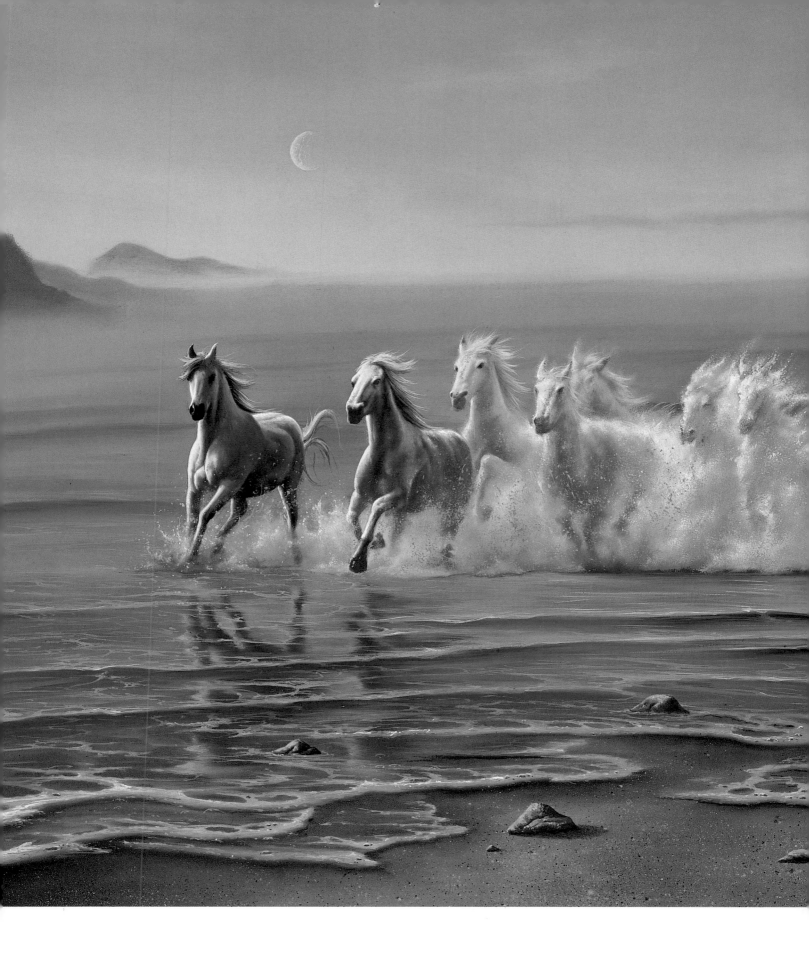

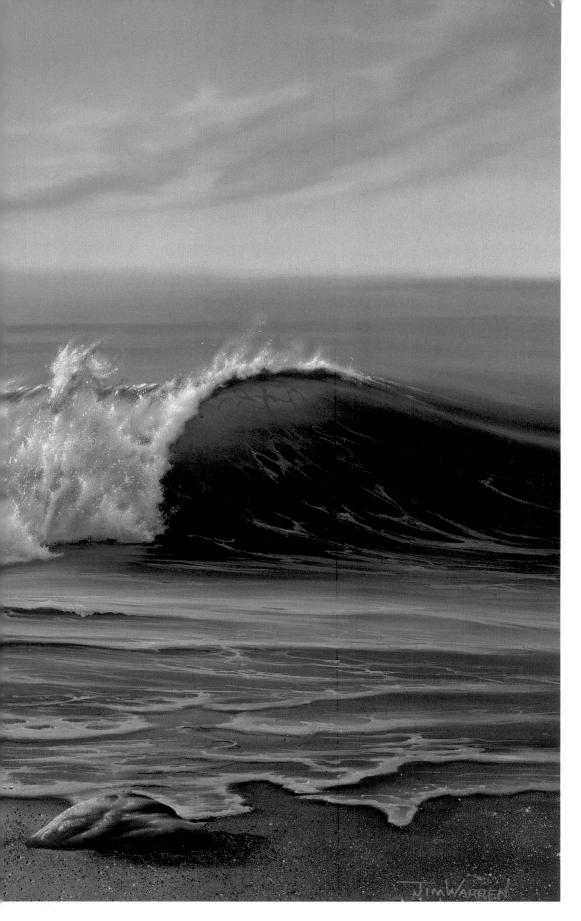

WILD WATERS

This painting uses my signature style of blending two or more common elements from the real world to create something that seems to belong to another one. The venture was successful: *Wild Waters* has been published as a limited-edition print and on greetings cards, puzzles and so on.

1993

24in x 36in (61cm x 91cm)

Available as limited-edition prints, many gift products

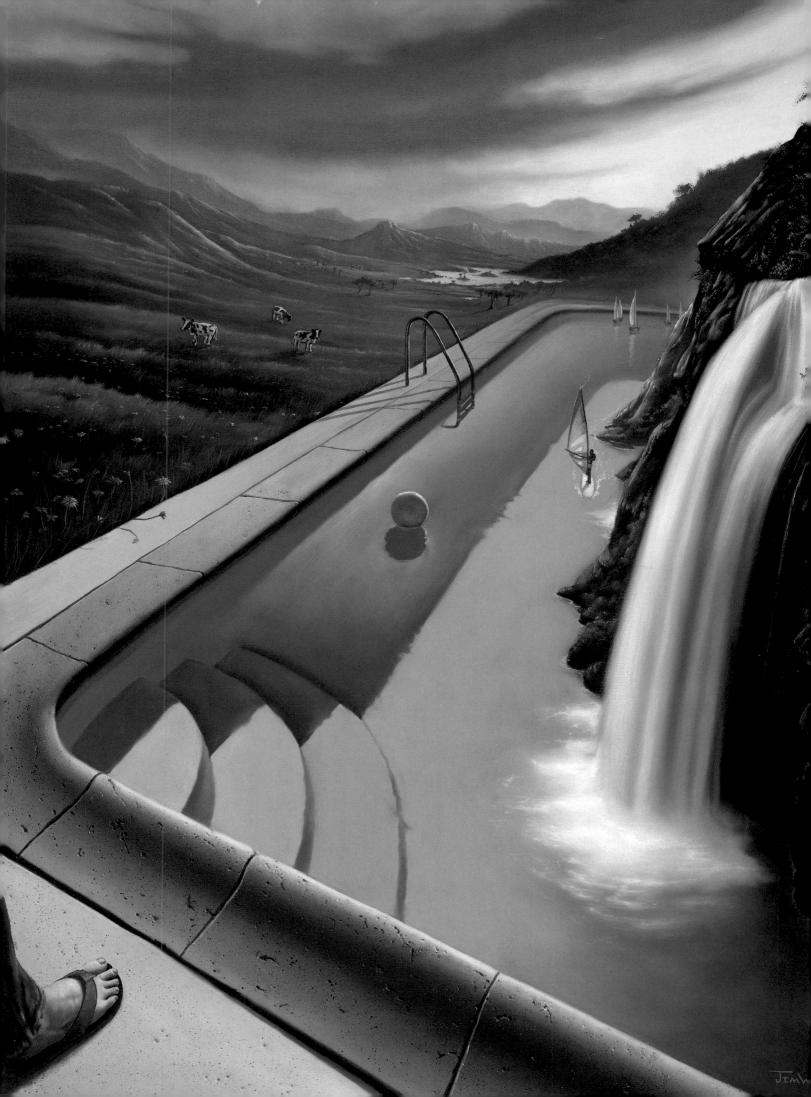

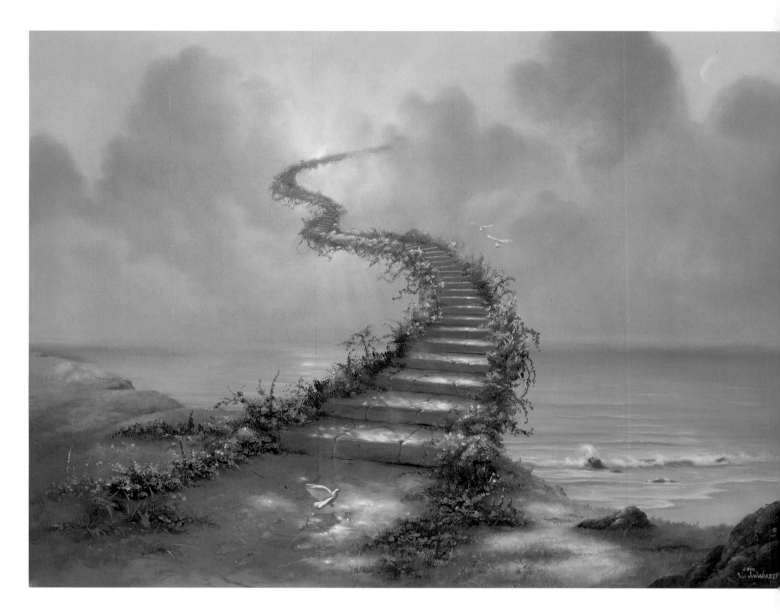

MAN AND NATURE *(left)*

The theme of this painting s the fairly simple, obvious one that Man and Nature must learn to co-exist, to adapt to each other in the same way as married couples do.

1994

24in x 30in (61cm x 76cm) Available as greetings cards

STAIRWAY TO HEAVEN

This painting symbolizes something that all the religions in the world have in common, and something that's felt even by those who have no religion at all: the belief in – or at least hope for – a higher, better place. And, yes, the painting was in part inspired by the Led Zeppelin song.

2000

30in x 40in (76cm x 102cm)

Available as limited-edition prints

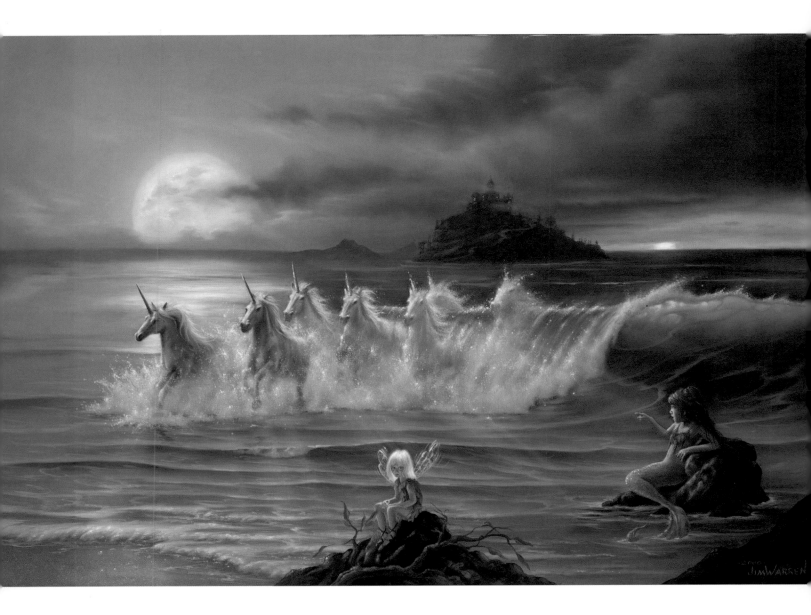

THEY ONLY COME OUT AT NIGHT

I've never really done much in the traditional genre-fantasy vein – fairies and unicorns and such – probably because it's all become too clichèd for me. This painting was born out of my observation of some of the freaks and unusual people who seem to come out only at night.

2000

24in x 36in (61cm x 91cm)

Available as limited-edition prints, greetings cards, puzzles

MERMAIDS' TEA PARTY *(right)*

I would imagine that mermaids would be very excited to play human games if they could find a nice private spot and persuade a little boy to fetch them their supplies.

1995

36in x 48in (91cm x 122cm)

Available as limited-edition prints, greetings cards, puzzles

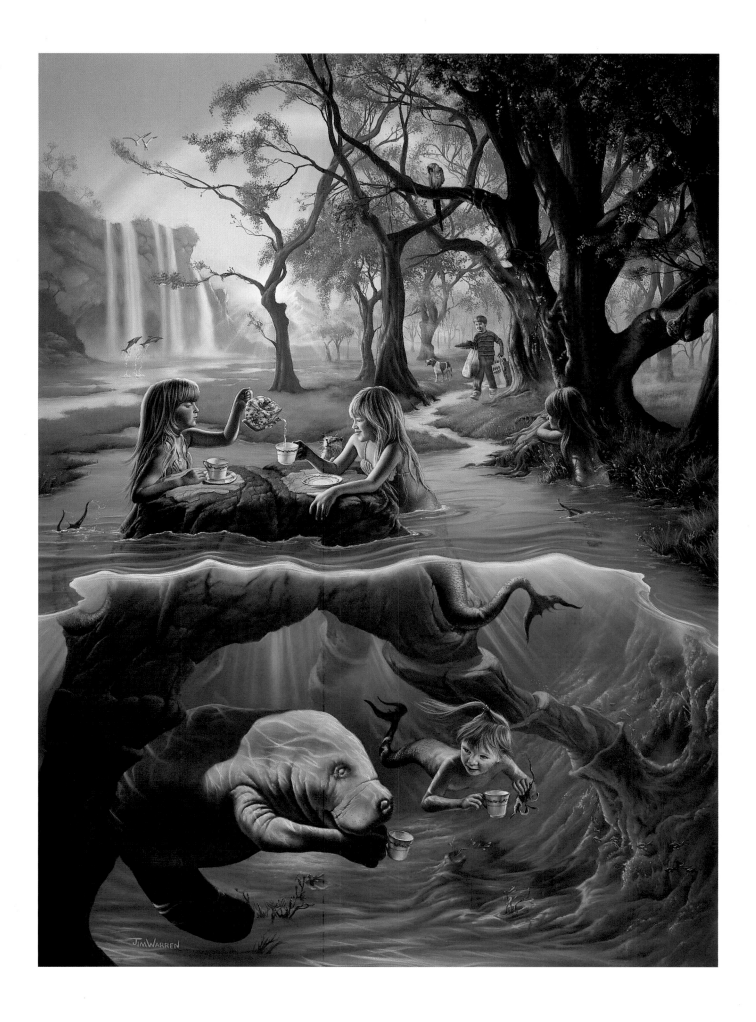

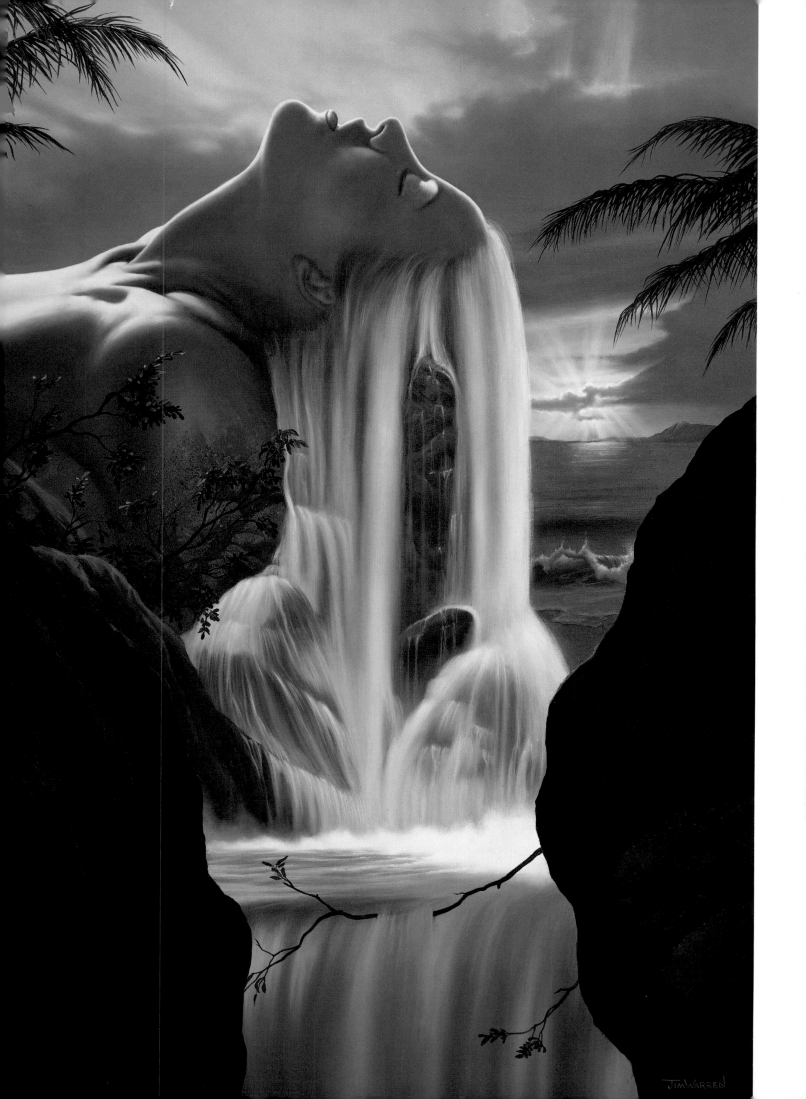

ISLAND DREAMS

If you have ever relaxed by the beautiful falls of Hawaii,
you have probably experienced the feeling of becoming
part of that environment.

1994

24in x 36in (61cm x 91cm)

Available as limited-edition prints, greetings cards

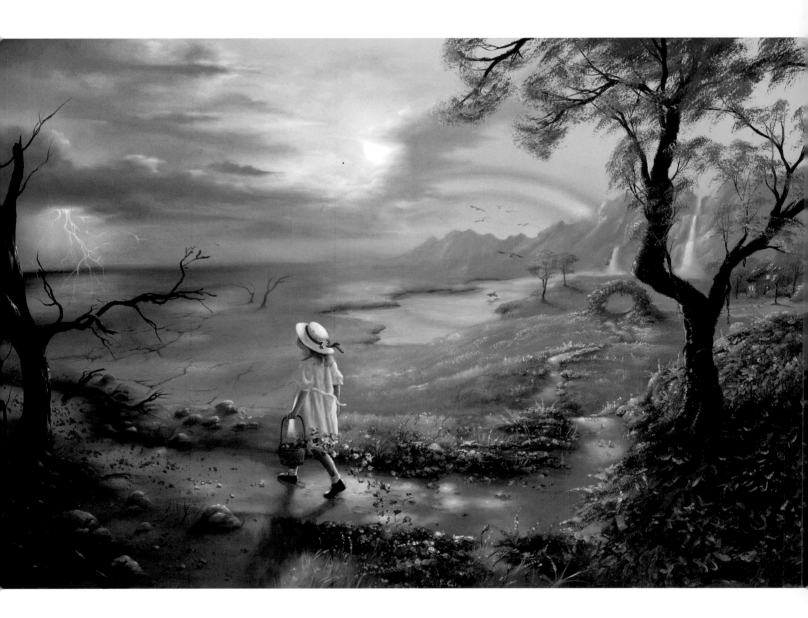

NATURE'S LITTLE HELPER *(above)*

Little girls in their Sunday School dresses have an amazing way of brightening up the
world. Little boys, on the other hand, have a knack for dirtying it up. I guess that keeps a
nice balance. This painting is very representative of my recent shift from painting human
figures to painting the beauty of Nature as my imagination sees it.

2000 24in x 36in (61cm x 91cm)

Available as limited-edition prints, puzzles

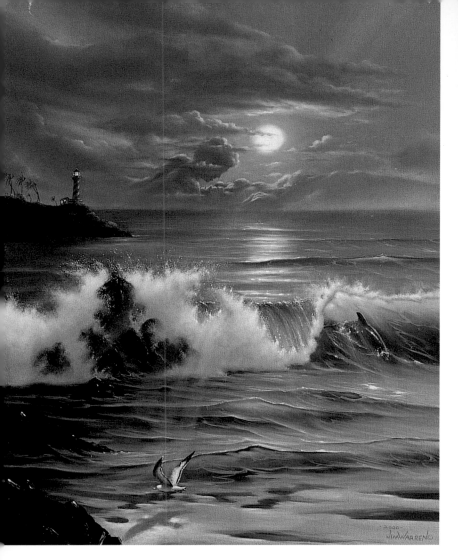
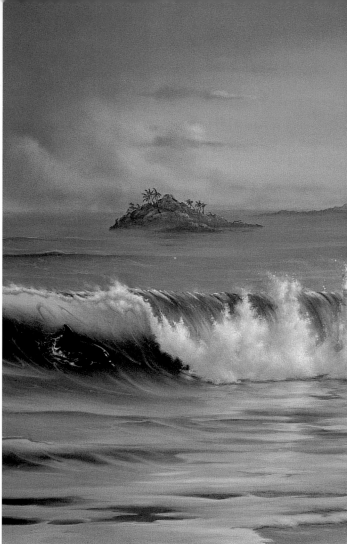

DREAMSCAPE SERIES *(above)*

For the new millennium, I set out to do three paintings – called (left to right) *Moonlit Romance, Galloping Waves* and *Evening Comfort*. I didn't know which to start first so I decided to design them to blend in with each other, while each still remaining a separate painting in its own right. The hard part was continuing on from one to the next before the paint dried.

2000

Moonlit Romance 24in x 30in (61cm x 76cm)

Galloping Waves 30in x 40in (76cm x 102cm)

Evening Comfort 24in x 30in (61cm x 76cm)

All available as limited-edition prints

RIDERS IN THE STORM *(right)*

One night as I walked out of a restaurant I saw a most spectacular Florida lightning storm. It wouldn't have been practicable to take a photograph, so instead I just stared for twenty minutes, with the lightning allowing me a split-second view every thirty seconds or so, and tried desperately to remember everything of this unique and dramatic light show. Afterwards I came home and immediately drew it on black paper with coloured pencils.

1998 22in x 28in (56cm x 71cm) Published as greetings cards

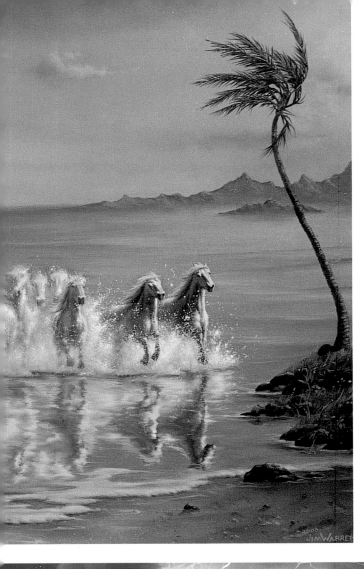
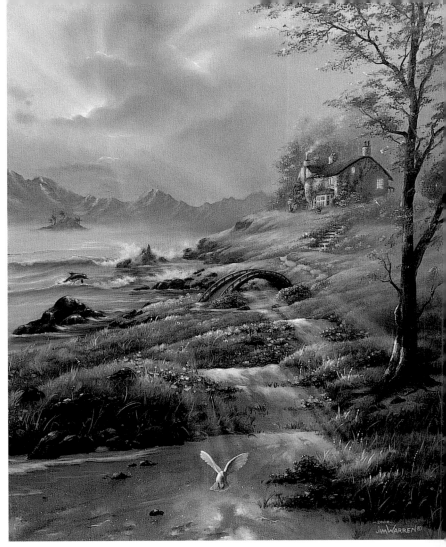
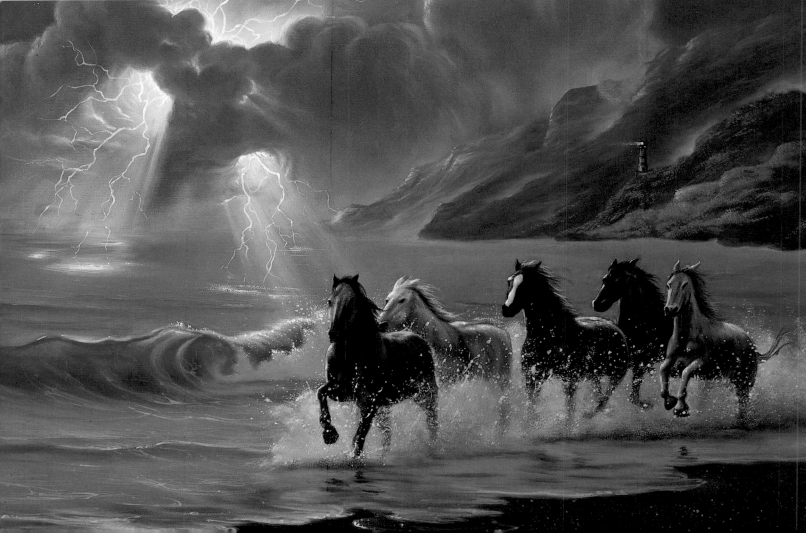

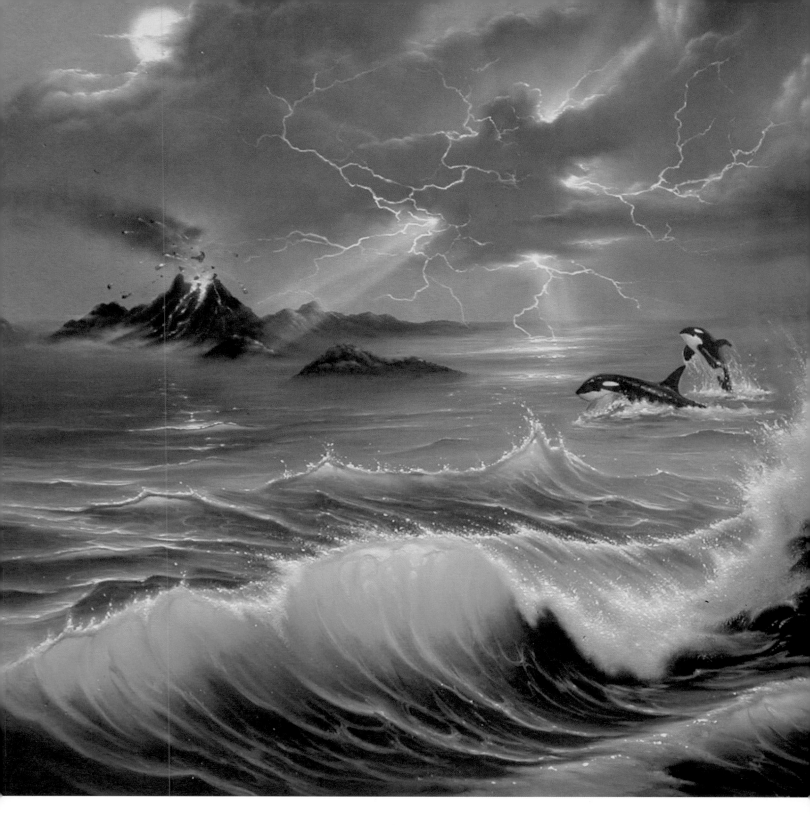

BEAUTY OF THE FURY

I did something with this painting I had never done before: I paid attention to where I had come up with the idea. I'd decided to start a new painting, but couldn't think of anything original. I wanted to do some kind of beautiful landscape, yet at the same time something more intense and dramatic than my usual landscapes. It suddenly came to me that some of the most dangerous elements in the world are also some of the most beautiful – such as lightning storms, volcanoes, tornados, crashing waves and, among the most beautiful creatures of the sea, the Orca killer whale.

1995 30in (76cm) diameter

Available as limited-edition prints, greetings cards, puzzles

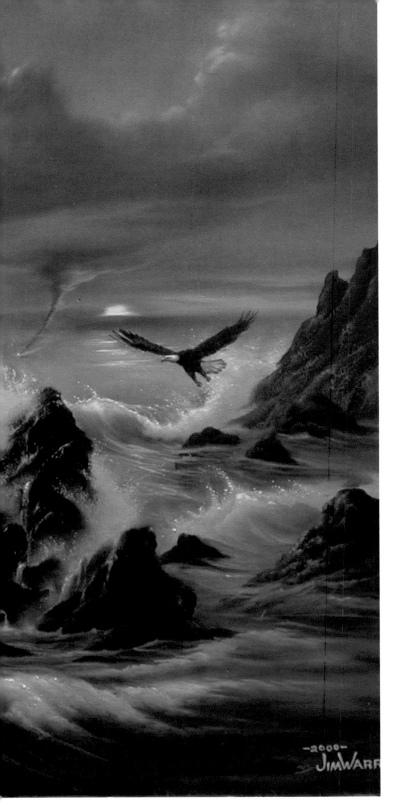

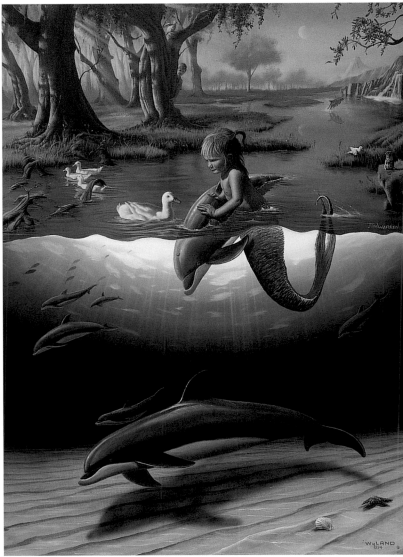

THE LITTLEST MERMAID

This painting was a collaboration with Wyland, one of the world's leading marine-life artist. Since his speciality is marine life and mine is people, the result here turned out to be, I think, the perfect mermaid painting. The model was my daughter Drew. Prints of these collaborations are shown at over thirty Wyland Galleries throughout the USA.

1994

36in x 48in (91cm x 122cm)

Available as limited-edition prints, many gift products

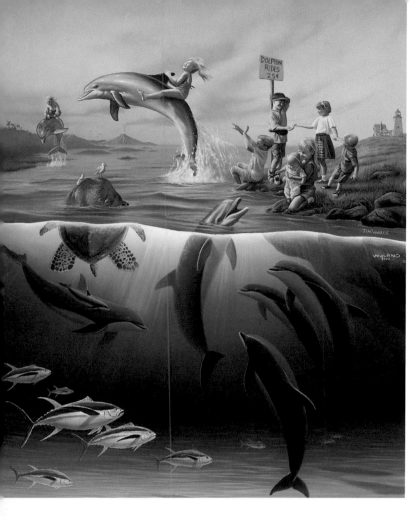

DOLPHIN RIDES

I met Wyland at the Los Angeles Art Expo in 1991, and within a month we had two collaborative paintings – this and *Mermaid Dreams* (see page 54) – completed and premiered at one of his gallery shows. Nobody can accuse us of being lazy! The model for the baby was my daughter Drew, then six months old; the other kids were my niece, cousin and neighbours, whom I used because they had that Norman Rockwell kids-next-door look.

1992

36in x 48in (91cm x 122cm)

Available as limited-edition prints, many gift products

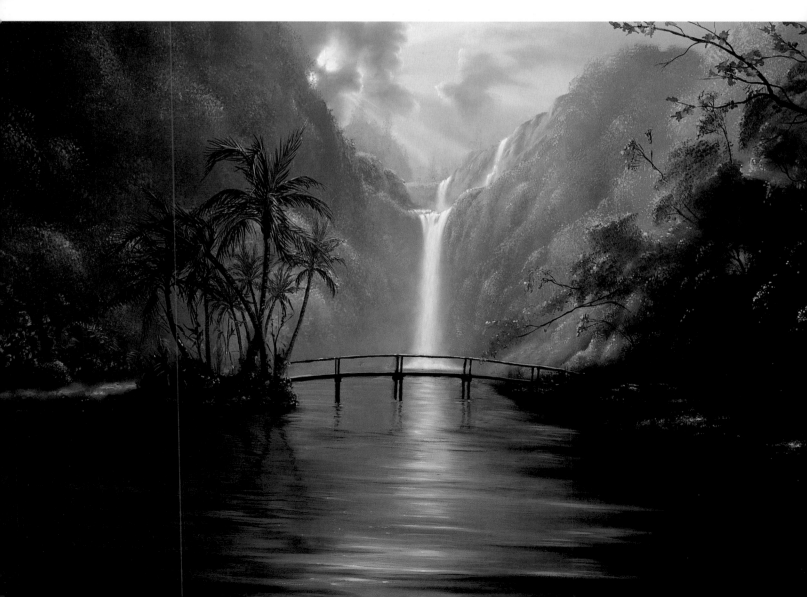

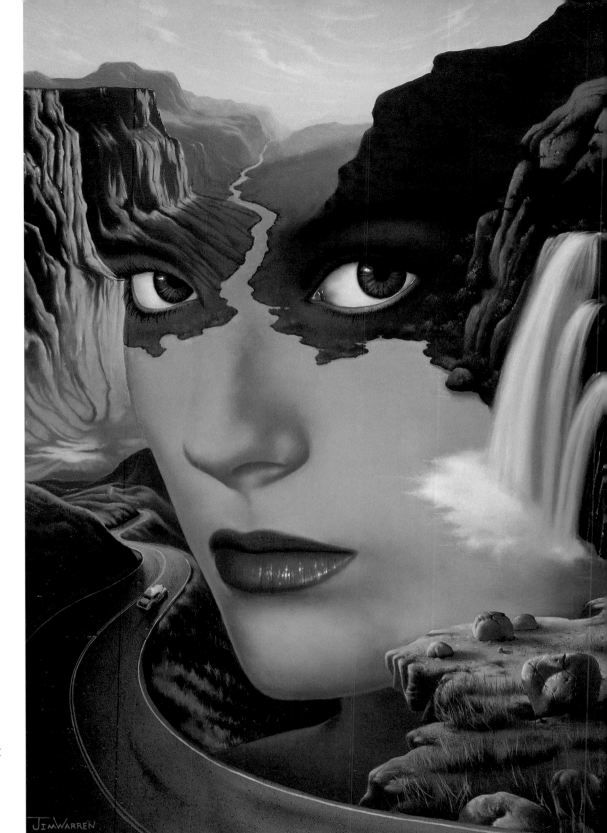

REFLECTIONS

People wonder how I can paint such wildly bizarre pictures sometimes and yet also such serene and beautiful ones at other times. Which is the real me, they ask? Well, it's *all* me. Art is a matter of communication, and there are occasions when I want to shock, surprise or just make people think, and others when I want simply to express the more spiritually meaningful, natural and beautiful side of life.

1997
20in x 24in (51cm x 61cm)
Published as limited-edition prints

MOTHER NATURE *(above)*

The environment has always been a major theme in my art. Here I have Mother Nature peering out at us in all her serene beauty. Some Nature lovers ask why she's wearing lipstick. It's artistic licence, that's why …

1989 22in x 28in (56cm x 71cm)
Available as limited-edition prints, T-shirts

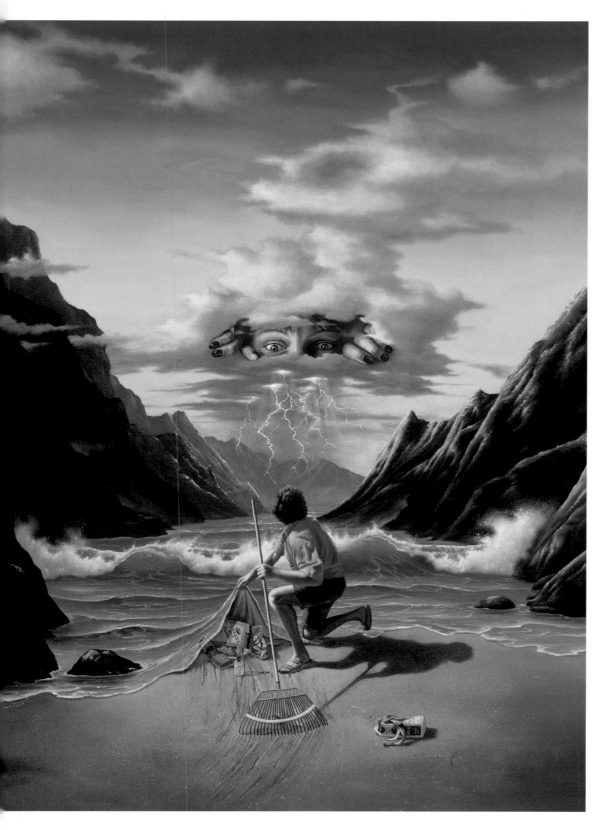

TOGETHER
AGAIN *(right)*

This painting is my sort of partial answer to the question: Does true love die when we do, or does it go on and on?

1998

24in x 30in (61cm x 76cm)

Available as limited-edition prints

DON'T MESS WITH MOTHER NATURE

It's probably because I grew up in the 1960s that so many of my paintings have ecological messages. Here the trash being swept under the carpet of the sea is the packaging for 100% fat milk, cookie-jar cereal and yuck cola.

1994 36in x 48in (91cm x 122cm) Available as limited-edition prints

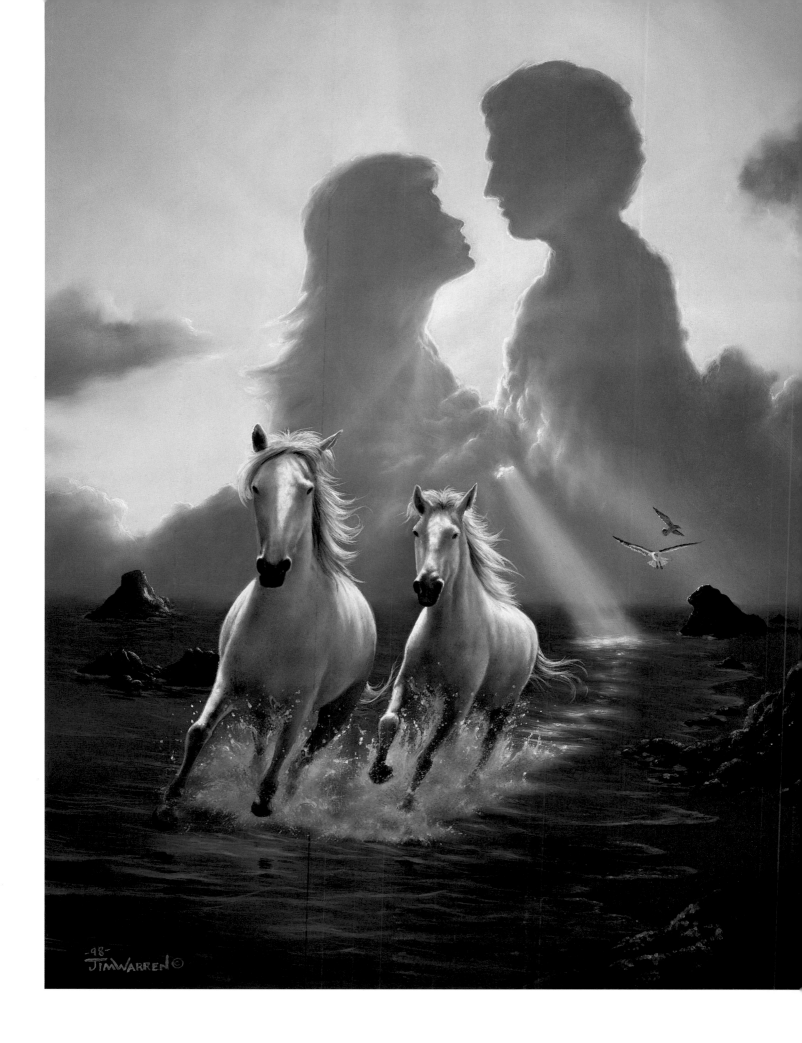

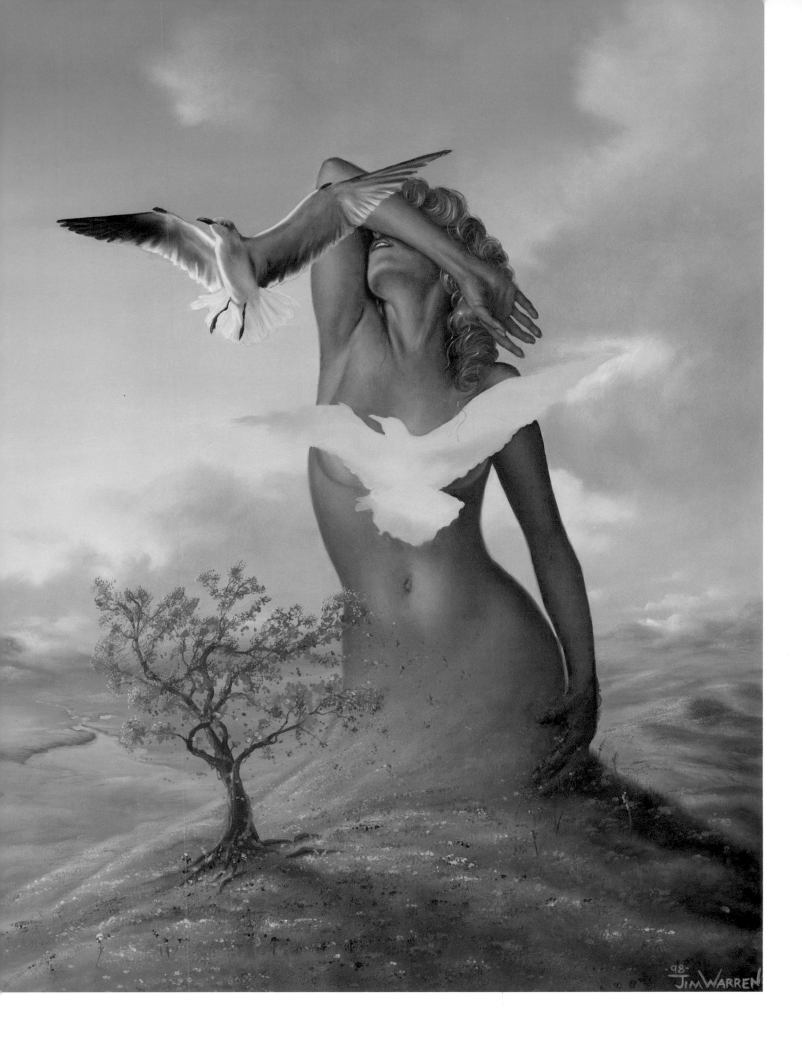

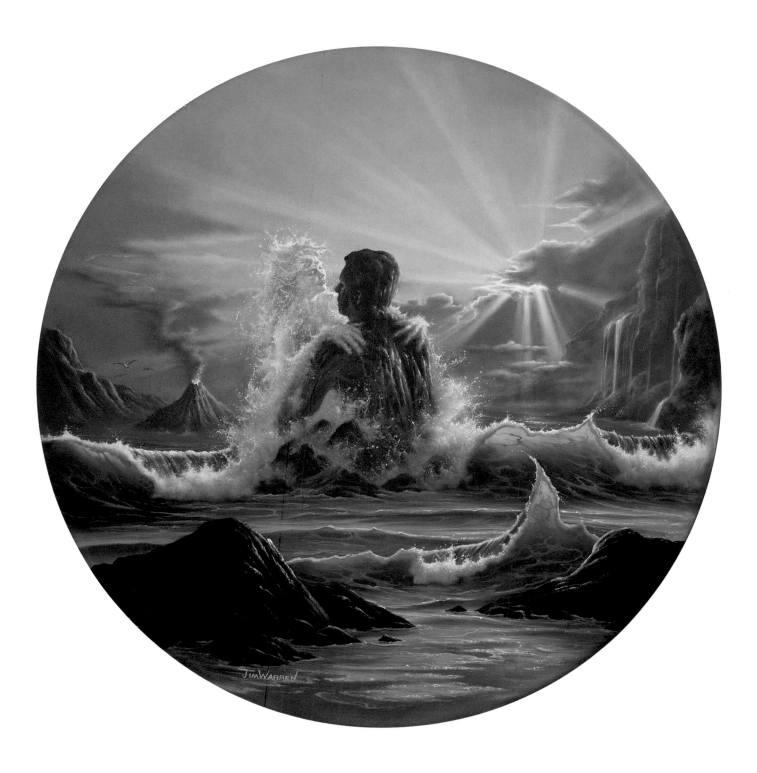

FLY AWAY (left)

Although my paintings often seem to have had a lot of thought put into them, sometimes I have no idea myself what they actually mean – if indeed they 'mean' anything at all. This is one of those.

1998

24in x 30in (61cm x 76cm)

NATURE'S EMBRACE

In symbolism we have the woman soft and flowing like water, the man tough and unshakable like a rock. That is what came to mind one day as I watched Nature at work while standing by the ocean's shore.

1995

30in (76cm) diameter Available as limited-edition prints

SPLASH OF LIFE

Early on in my career my dad asked me if I would ever run out of ideas. Thirty years later, I think I can safely give him an answer to that one. There are times I think of ideas much faster than I can paint them. This painting shares a theme that runs through many of my paintings: ocean waves forming into living things – hence the title *Splash of Life*.

1998

24in x 36in (61xm x 91cm)

ROMANTIC DAY *(right)*

Romance is a central theme in many of my paintings – everything from the beauty and joy of love to the sadness of losing it.

1992

24in x 36in (61cm x 91cm)

Available as limited-edition prints, greetings cards, posters

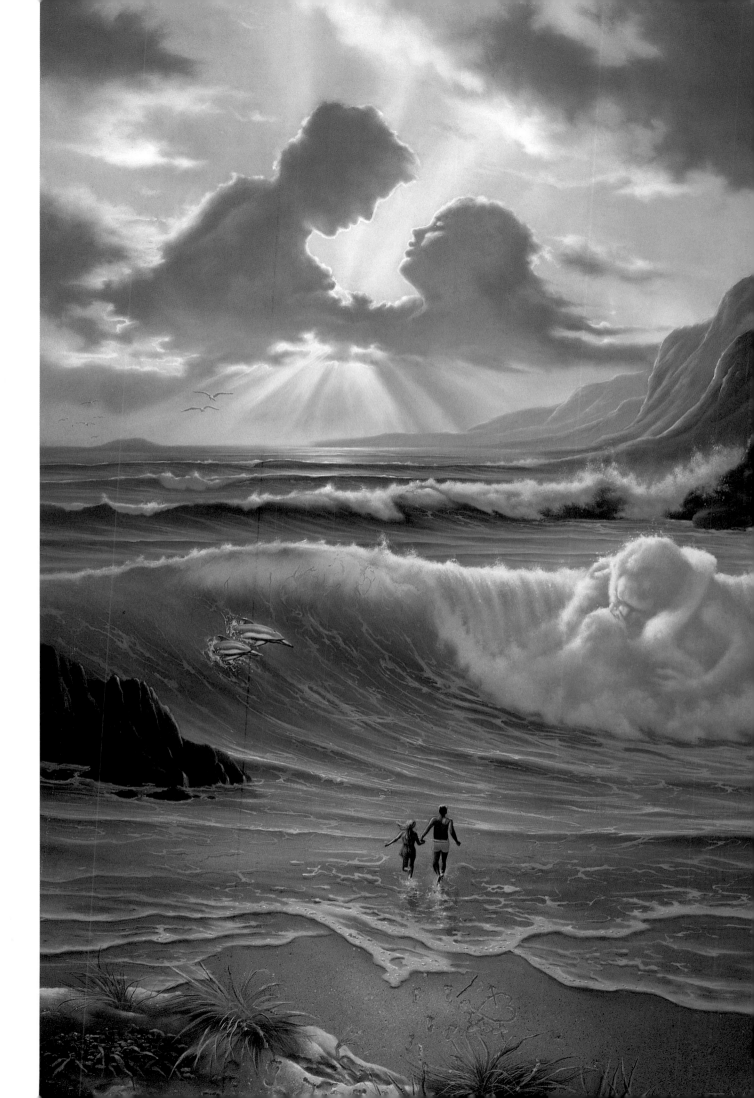

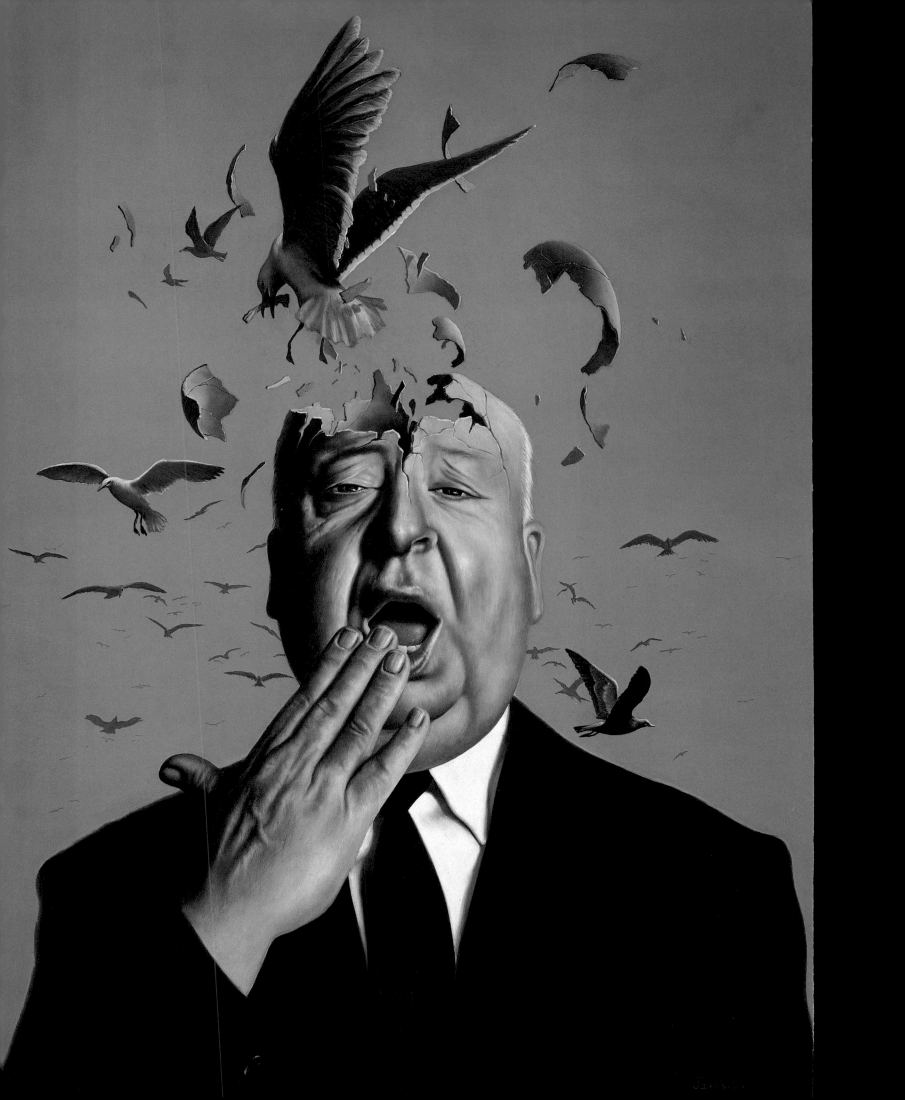

BIRDS

I've always loved Hitchcock movies ... and that face of his was a piece of art in itself.

1990

24in x 30in (61cm x 76cm)

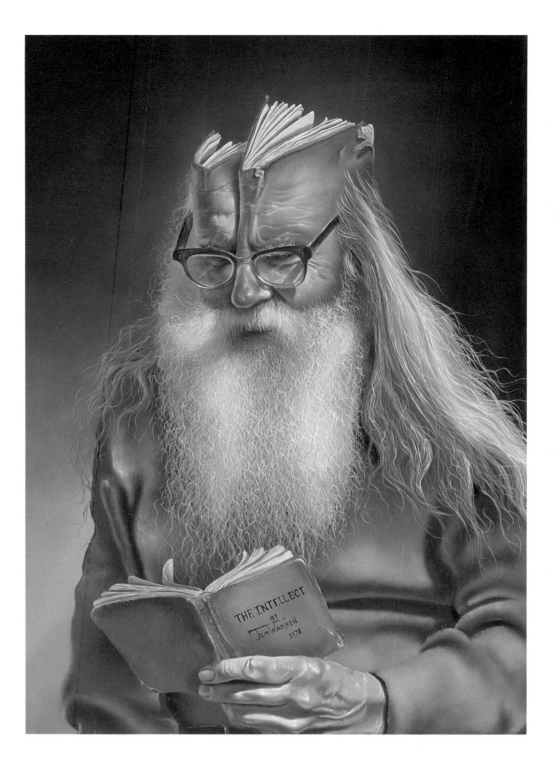

THE INTELLECT

This was based on a man I met who had a flowing white beard and hair like Santa Claus. I told him I wanted to paint him, and he let me take photographs. A while later, when he saw the painting I'd done based on the photographs, he was pretty surprised – in real life he was not at all intellectual. He is the only person I've painted who has complained about the finished piece. Good thing it wasn't a commissioned portrait!

1976

18in x 24in (46cm x 61cm)

Available as limited-edition prints

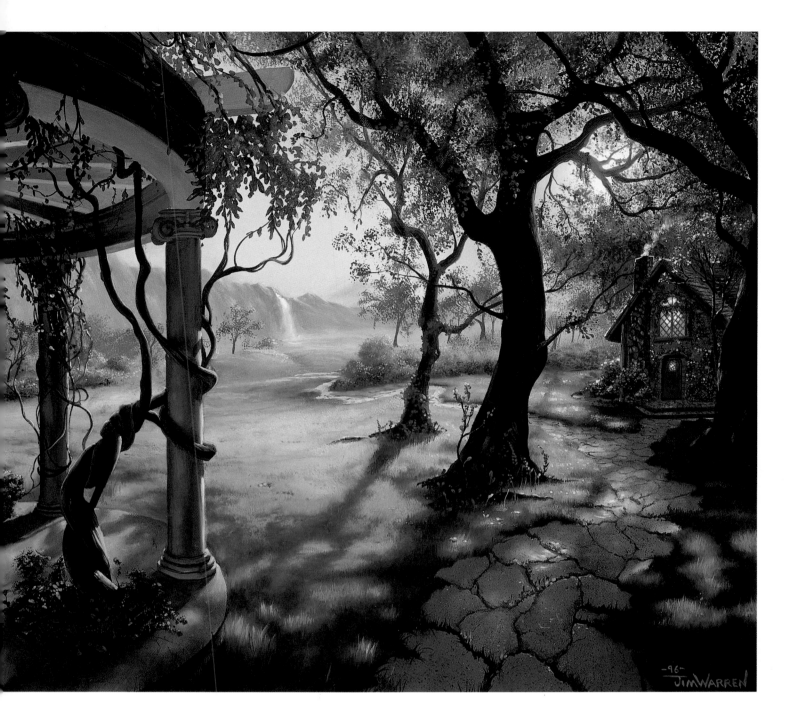

AN INVITING PATH

Paintings are often like windows to a world you would
love to be a part of … especially if you're looking through
the window from the inside of somewhere like, shall we
say, an office building in downtown LA.

1997

20in x 30in (51cm x 76cm)

Available as limited-edition prints, puzzles

CHILD'S PLAY (right)

I really enjoy painting children doing what they do best: using their imaginations. It's funny how as children we often have the ability to make the world whatever we want it to be, and then as adults we often spend too much time complaining about the way it really is.

1991

24in x 36in (61cm x 91cm)

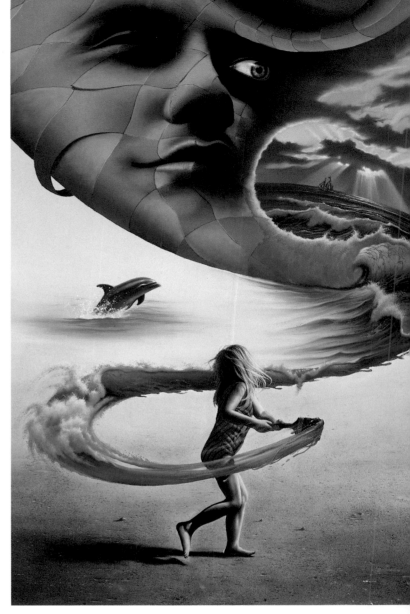

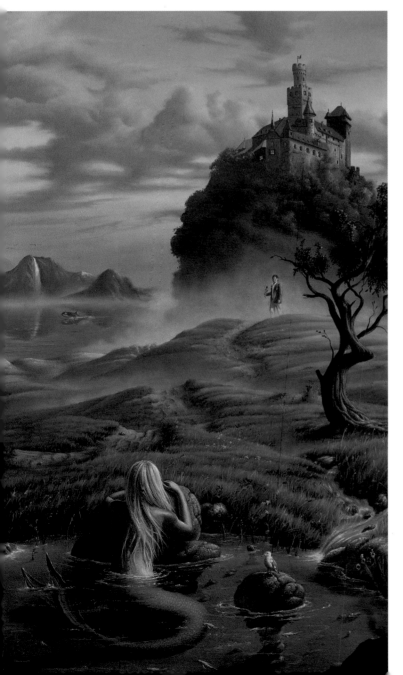

THE PRINCE AND THE MERMAID (left)

My paintings are sometimes like stories without words. This one was inspired by various movies I'd seen in which circumstances dictated that two lovers could love each other only from afar.

1996

24in x 36in (61cm x 91cm)

Available as limited-edition prints

CAT WOMAN

What I have tried to achieve in many of my paintings is the effect of the real mixed with a touch of the unreal, to make you feel you're actually seeing something that in reality couldn't possibly be. This particular example is subtle enough that some people don't notice the unreality first time around.

1989

24in x 30in (61cm x 76cm)

Available as limited-edition prints

MOUNTAIN BEAUTY *(right)*

Although I pride myself on my originality, I do acknowledge that I have had various artistic influences over the years, including Dalí, Magritte, Rembrandt, Monet, Norman Rockwell, Andy Warhol and Peter Max, to name just a few. *Mountain Beauty*, however, shows no real influence from any artist, only my own trademark blend of reality and imagination.

1992

24in x 30in (61cm x 76cm)

Available as limited-edition prints, posters

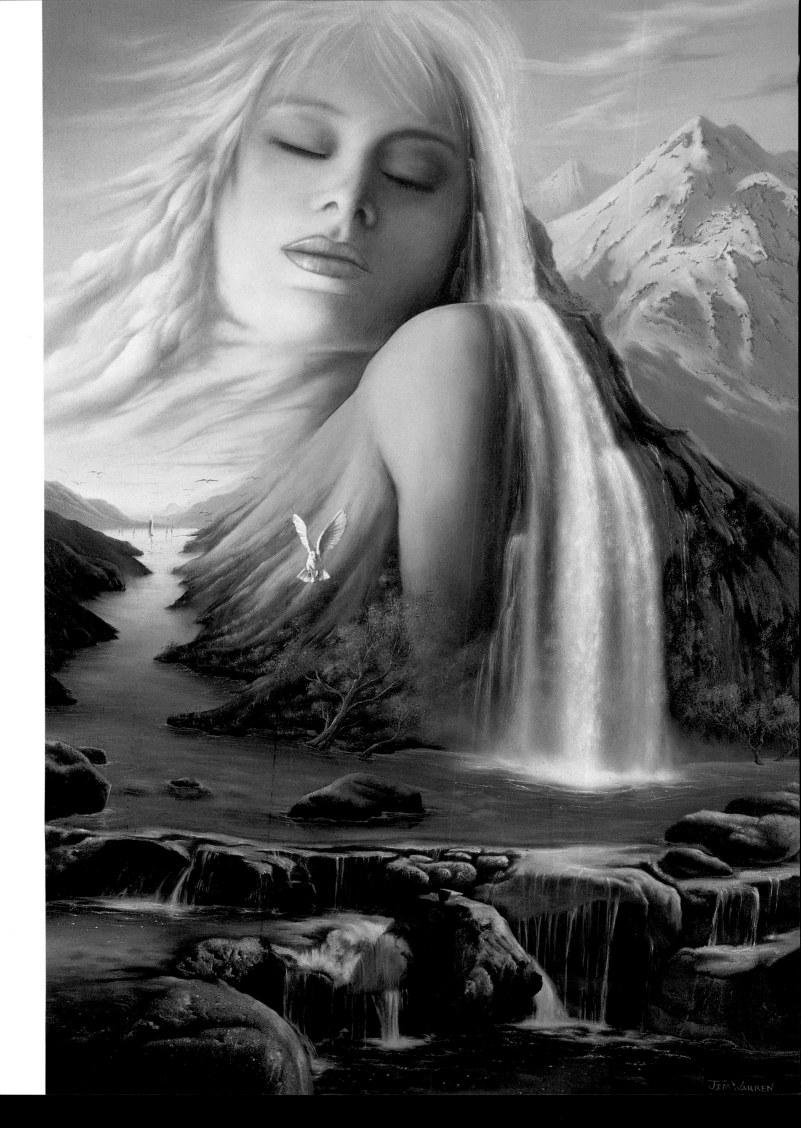

JIM WARREN

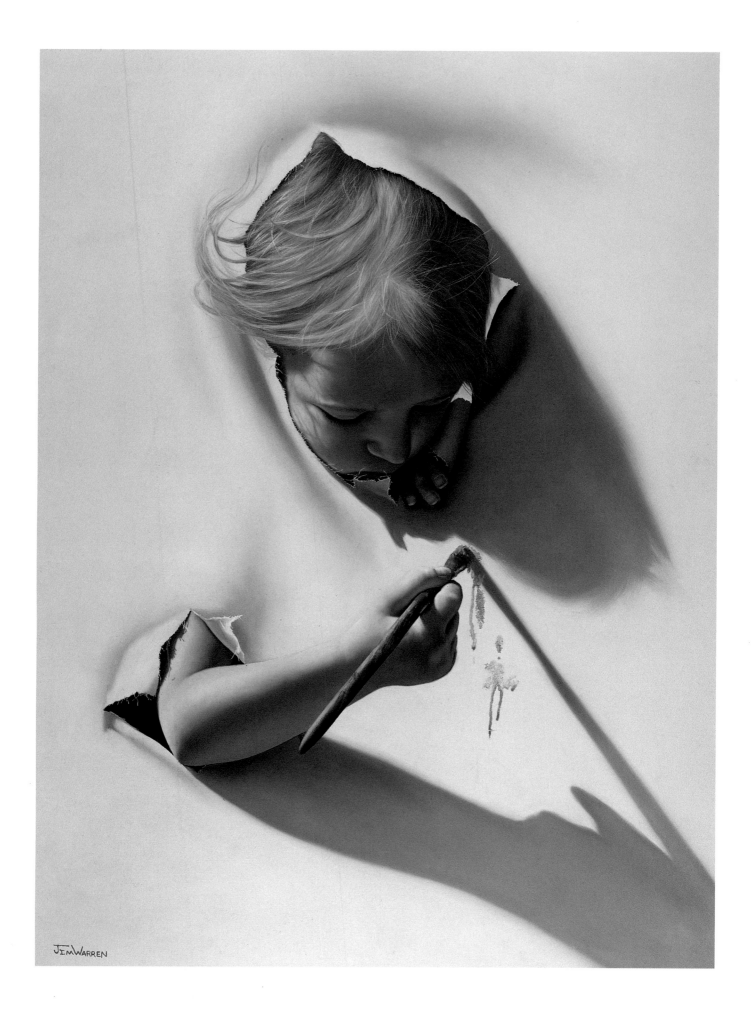

AWKWARD AGE

(left)

Having small children, I've been watching for the past eight years their attempts – made with the best of intentions – to achieve what they can see adults doing. I had to set a small drawing table in my studio for my kids so that they wouldn't attempt to finish my paintings for me.

1992

24in x 30in (61cm x 76cm)

Available as limited-edition prints

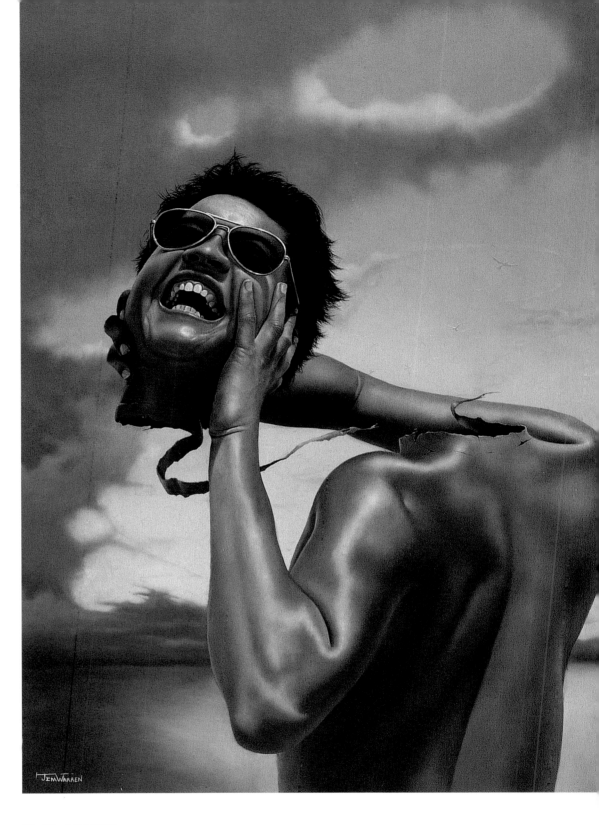

THE JOKER

The versatility of my subject matter is what keeps me interested in painting year after year. For this painting I wanted to do something a bit wacky and humorous. While at the beach I photographed a friend holding a bag in his hands and then took a separate shot of his face. I kept in mind the placements of these two shots when it came to doing the final painting. This picture was used as the cover for a card collectors' price guide in 1994 and later, in 1998, was reused as a cover for the magazine *Heavy Metal*.

1986 24in x 36in (61cm x 91cm)

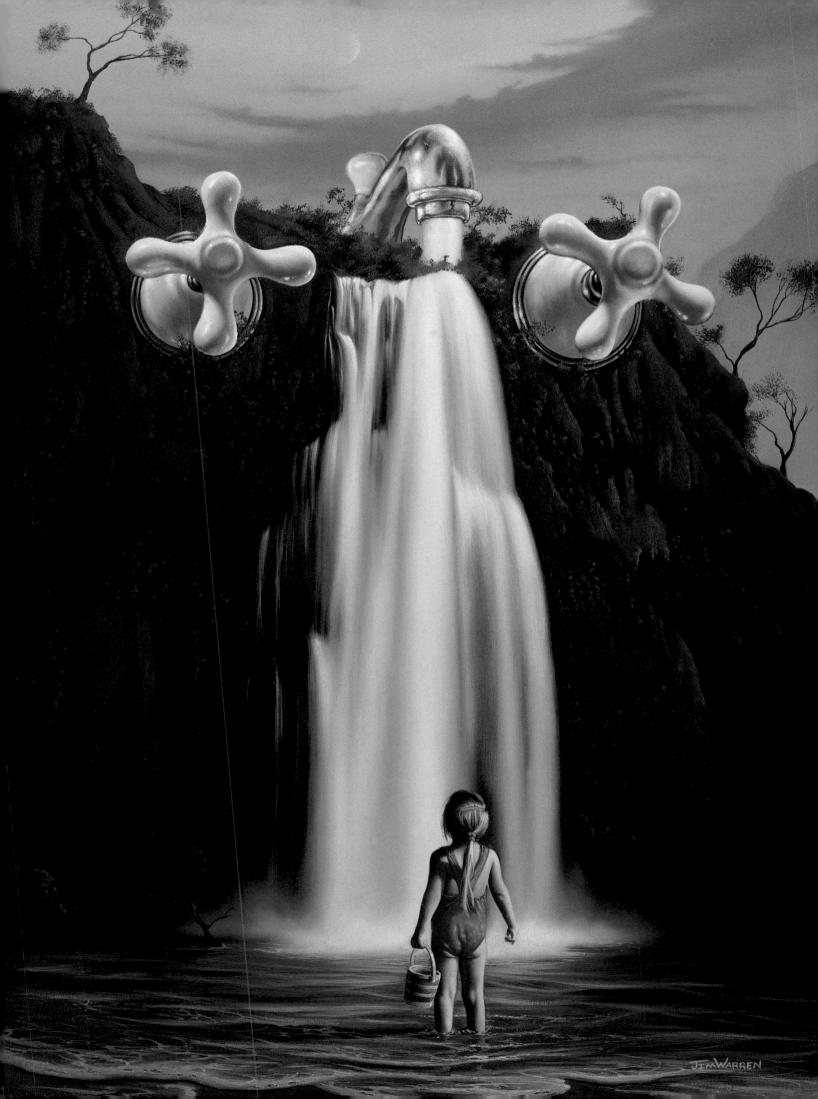

MYSTERIES OF
LIFE *(left)*

My two children are currently five and eight years old. Like kids everywhere, they ask very interesting questions such as 'Why does the moon follow us when we drive?' and 'How is water made?' and 'Are we rich?' And they expect nothing less than a full answer to those questions.

1992

24in x 36in (61cm x 91cm)

Available as limited-edition prints, greetings cards

LAND & SEA

This was done as the cover for the Signet Books edition of Mary Gentle's young-adult novel *Hawk in Silver*, and is one of about two hundred book covers that I painted in the late 1980s. Each one was a challenge and provided a learning experience equal to or better than anything I could have got in art school.

1986

18in x 24in (46cm x 61cm)

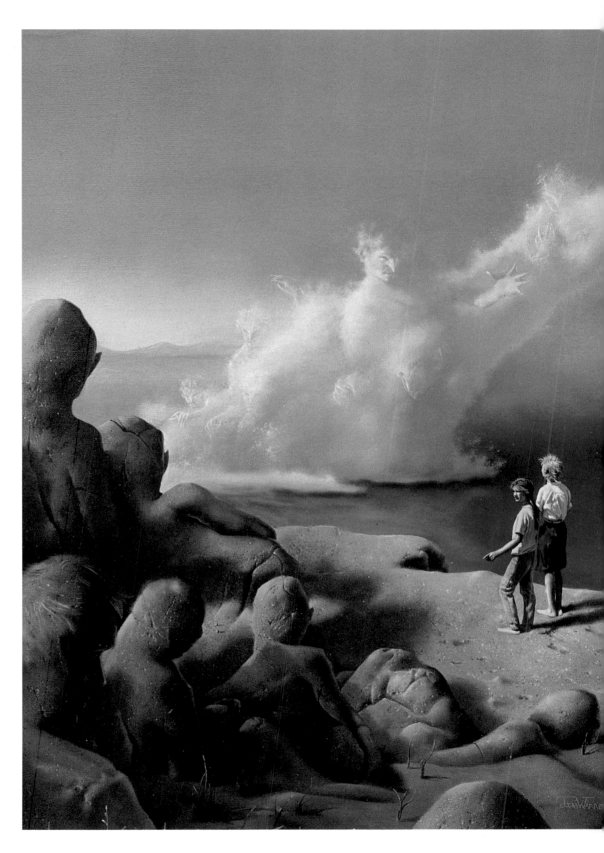

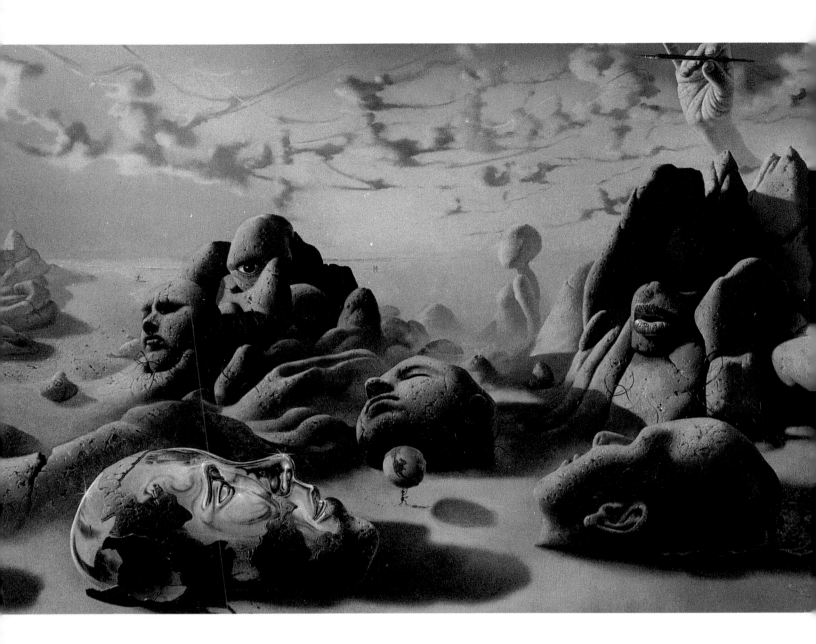

BIZARRE

Bizarrely enough, this was done for a Jackson Five-like R&B group called The Sylvers. They wanted bizarre, so I gave it to them. This painting, and one that I did for the rock star Prince, each took a month to complete, the longest I've ever taken for a single painting.

1985

24in x 36in (61cm x 91cm)

THE WAY HOME *(right)*

I spotted the scenery for this painting when I was leaving a house in Seattle after a photo shoot. It instantly caught my eye and so I photographed it, and a year later I finally painted it, adding some extra greenery, purple flowers and a few rays of sunlight shooting through the trees.

1998

24in x 30in (61cm x 76cm)

Available as limited-edition prints

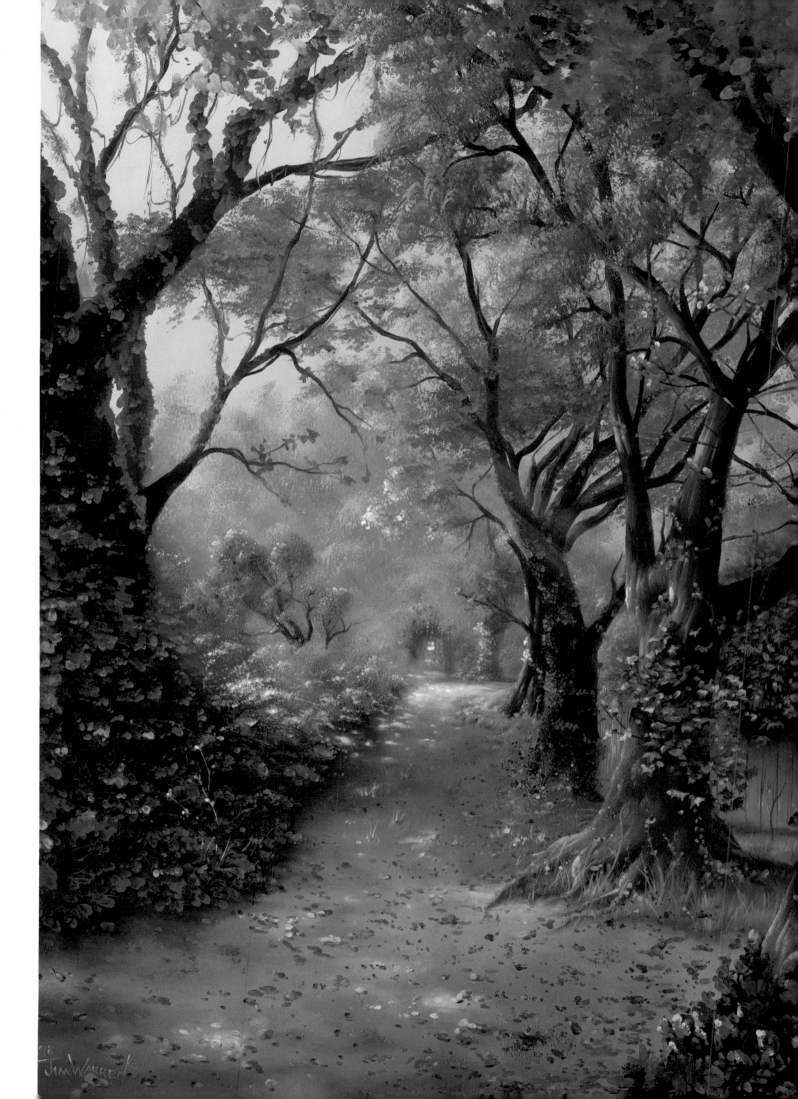

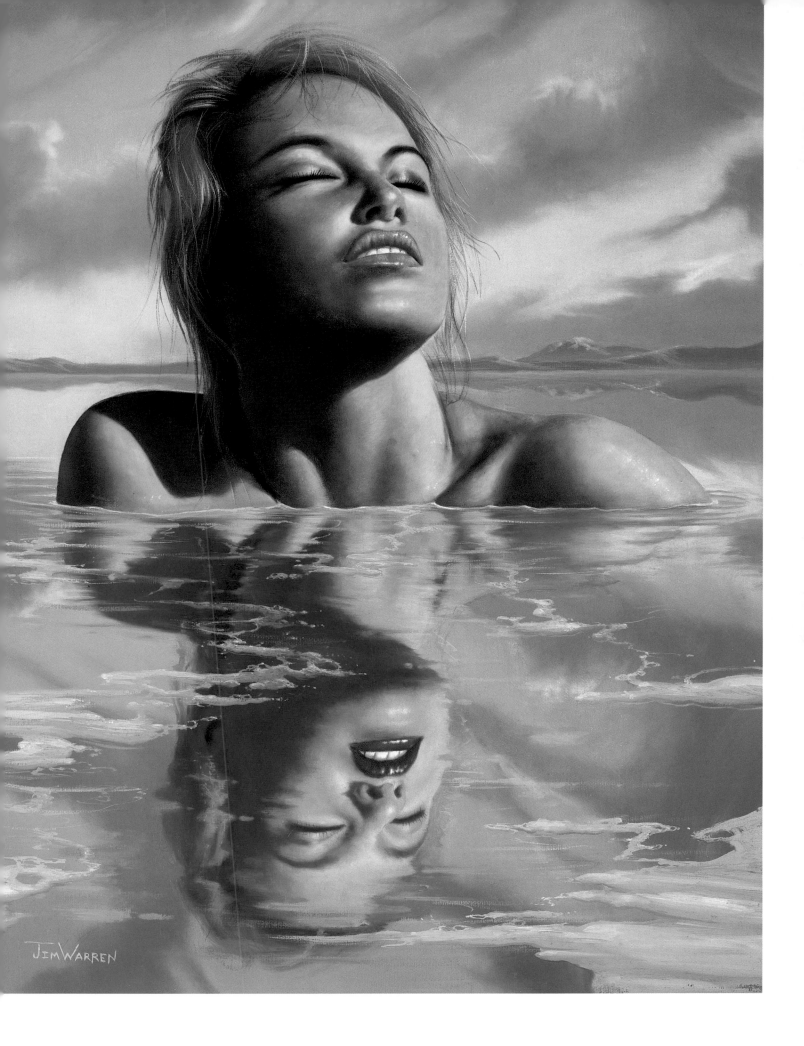

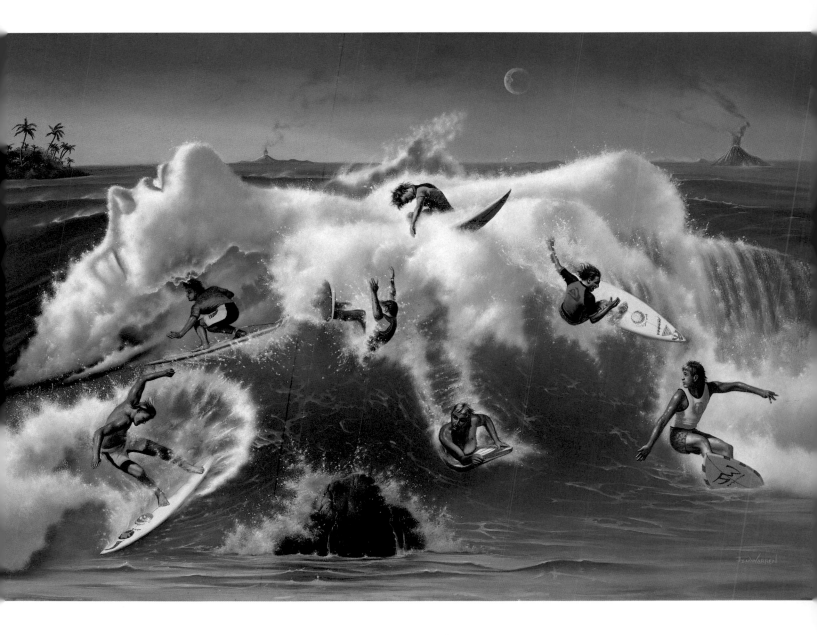

TRUE COLORS *(left)*

Titles are always very important to me, and often they sum up the painting in a few short words. Sometimes – as you may have noticed here and there – I name a picture after a favourite song of mine.

1991

20in x 24in (51cm x 61cm)

RIDE THE WILD SURF

Surfing, I always used to think, is a lot like chasing girls. If you're lucky and skilful you just might catch one, but if you're not you'll most likely get wiped out!

1989

24in x 36in (61cm x 91cm)

Available as limited-edition prints, posters

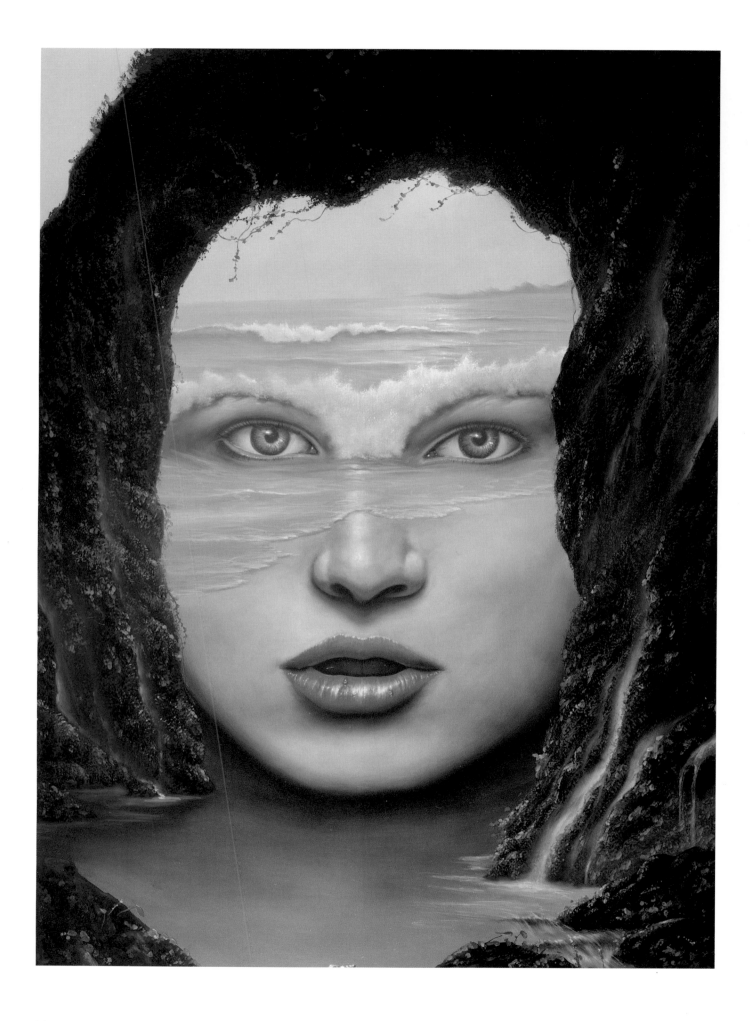

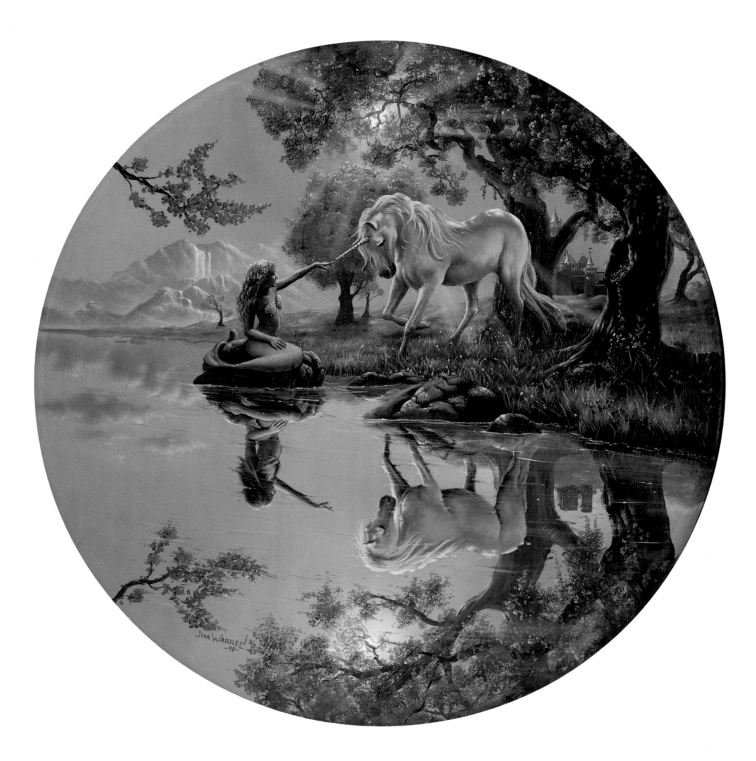

A PLACE OF MEMORIES (left)

It's painful how your memories lie in ambush for you when you lose someone you love: that special song or that special place makes it so hard to get the person you've lost out of your head.

1999

24in x 30in (61cm x 76cm)

IF I WERE A MERMAID
AND YOU WERE A UNICORN

Children's fantasies can be very real to them, so real that it's as if the child could reach out and touch them. Notice, in this picture, the reflections of the 'real' world below.

1997

30in (76cm) diameter

Available as limited-edition prints, puzzles, greetings cards

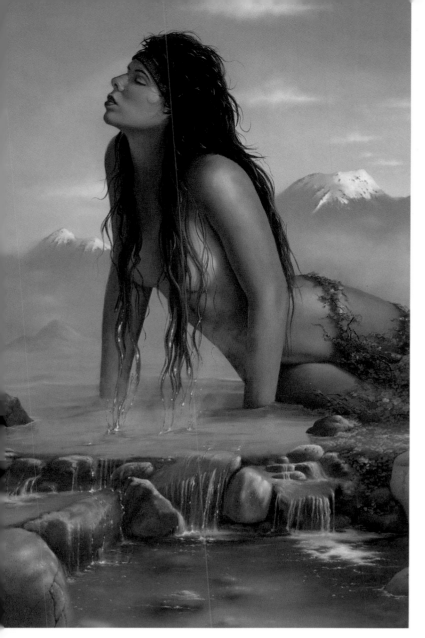

PEACEFUL MORNING *(right)*

My family and my career are often intertwined. My wife is my 24-hour-a-day in-house art director and my children and their friends do much of the modelling for me. My family also often travels to my gallery shows, so that vacation and work mix in places like Hawaii and Las Vegas. The idea for this painting came to me while we were on a family camping trip. The first thing I noticed when I woke up was the morning sun shooting rays through the trees.

2000

22in x 28in (56cm x 71cm)

Available as limited-edition prints, greetings cards

FIRE AND ICE

It surprises me when someone looks at an imaginative piece of art and thinks the artist must have been on drugs when he or she painted it – otherwise where could all those fantasticated ideas have come from? My own personal observations have shown me that drugs lower creativity, not to mention IQ.

And not just illegal drugs: I feel that too many doctors are prescribing drugs such as Prozac and Ritalin to their young patients, in an attempt to curb the 'normal' problems of growing up.

No drugs were used in this or any of my paintings.

2000

24in x 36in (61cm x 91cm)

Available as limited-edition prints

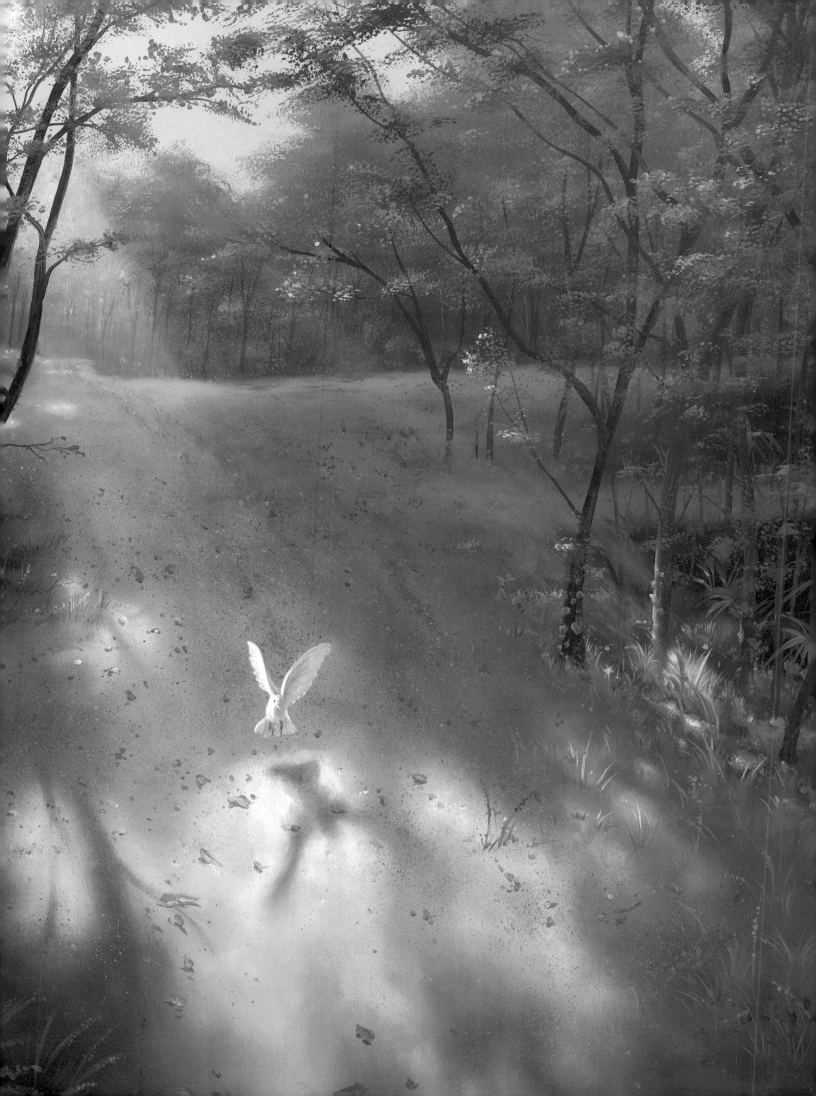

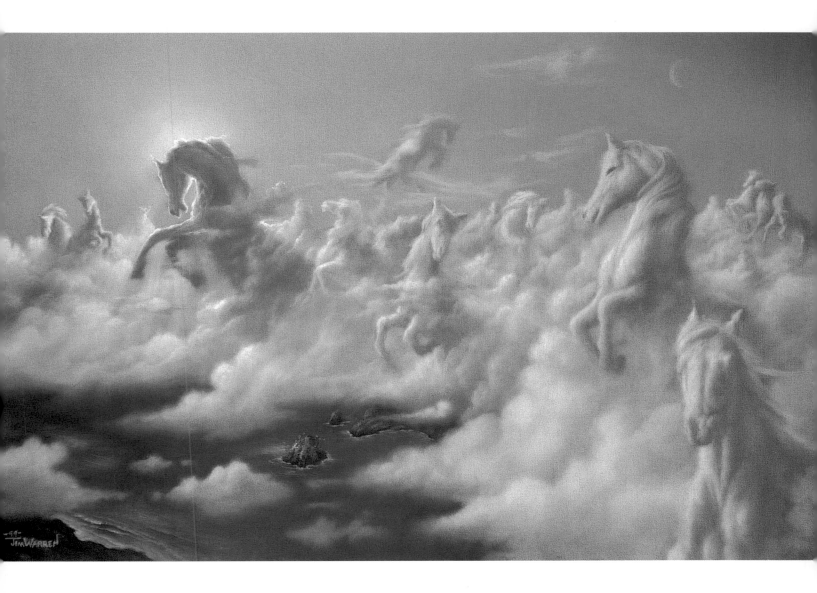

ABOVE THE CLOUDS

One day while I was travelling aboard an aeroplane, I particularly noticed the interesting shapes the clouds were making when seen from above: they looked like hundreds of wild horses. That's where this picture came from. Mother Nature is truly the best artist of us all!

1999

24in x 36in (61cm x 91cm)

Available as limited-edition prints, greetings cards, puzzles

PLEASANT DREAMS *(above right)*

A friend sent me an e-mail which ended with the words 'Pleasant Dreams'. That sounded to me like a great title for a picture, and so I painted this. Although some people have suggested I paint my dreams, this isn't in fact the case: I just paint what I imagine. The big difference is that we do not have any control over dreams whereas over imagination we do.

1998

24in x 20in (61cm x 51cm)

Available as limited-edition prints

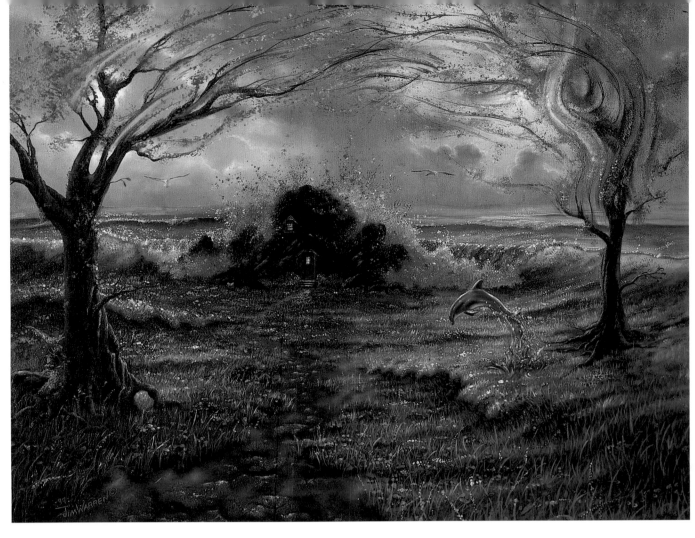

SOUL STORM (right)

When it comes to illustrations, particularly in the horror genre, special effects are often called for. As the preliminary photography for this painting – which was done as the cover for the Tor Books edition of Chet Williamson's novel *Soulstorm* – I shot pictures of a friend through a big sheet of Mylar paper, which has a reflective look similar to that of a funhouse mirror. The picture won the Award of Excellence from the Illustration Guide in 1987.

1986

24in x 36in (61cm x 91cm)

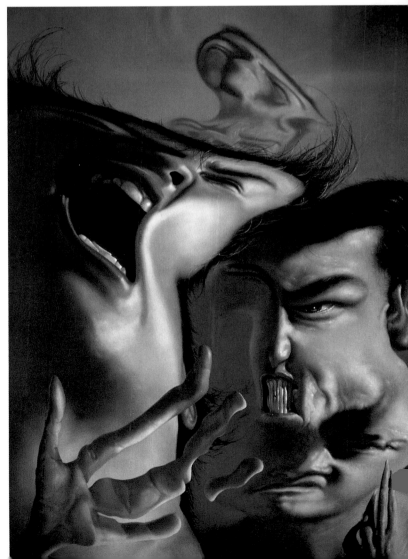

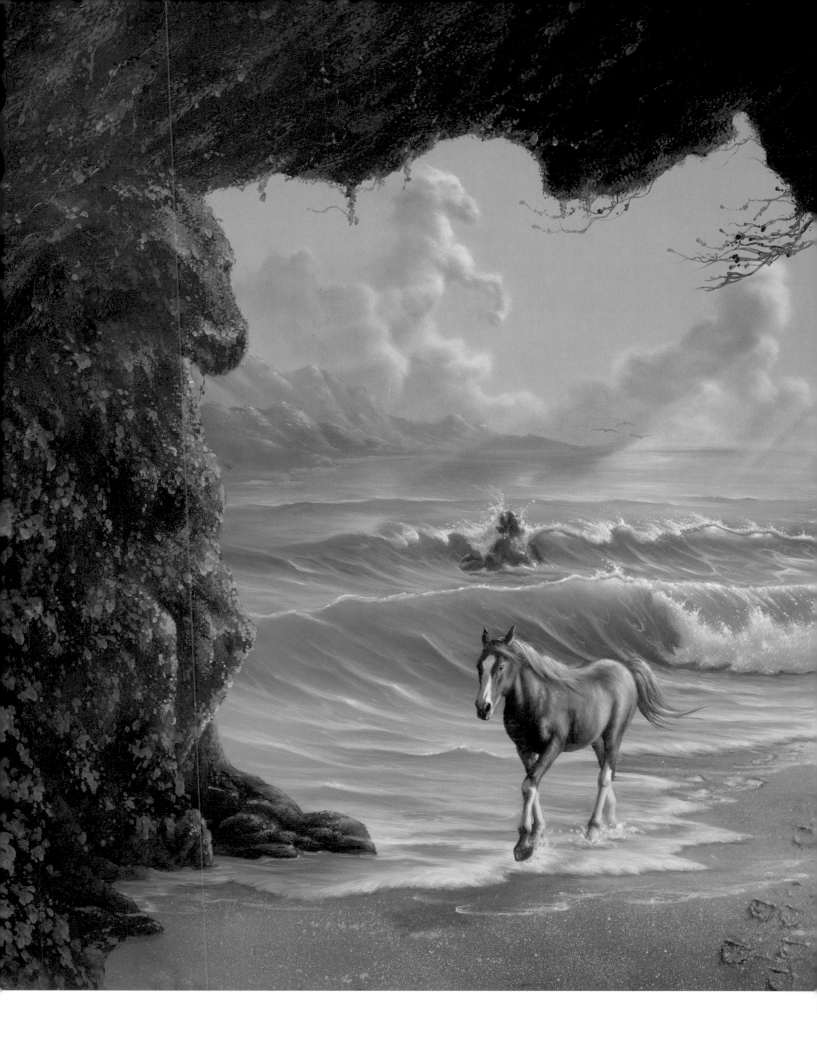

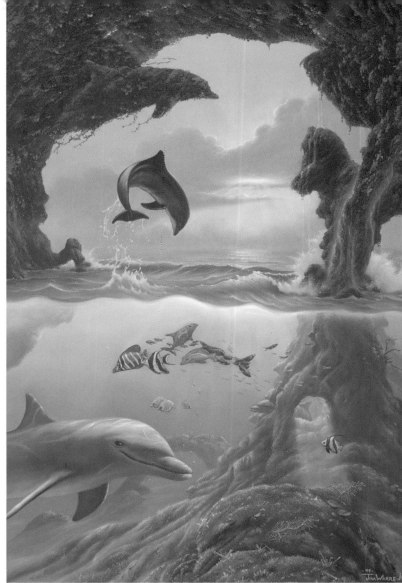

SEVEN DOLPHINS *(above)*

Remember those little drawings in the activity books you were given to play with as a child, where you had to find the hidden pictures? This one is for kids of all ages.

1999

24in x 36in (61cm x 91cm)

Available as limited-edition prints, puzzles,

greetings cards

SEVEN HORSES

The horses in this painting range from the obvious to the near–impossible. Hint: just because the title says there are seven horses doesn't mean you can see them all!

1999

24in x 30in (61cm x 76cm)

Available as limited-edition prints, greetings cards

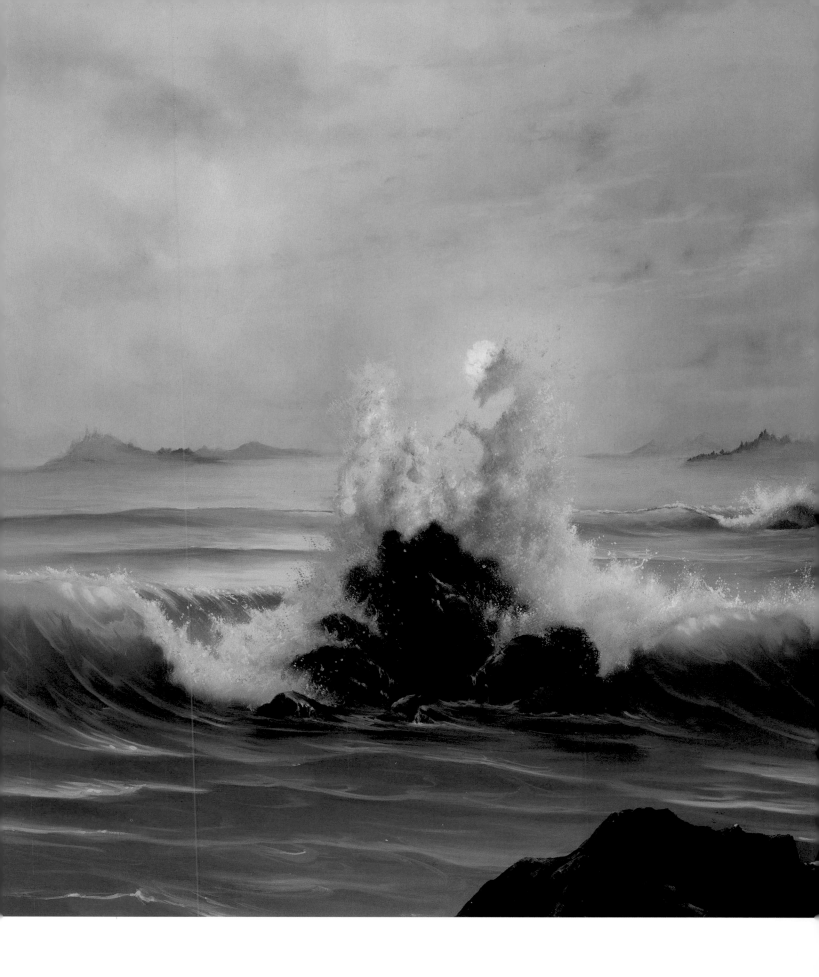

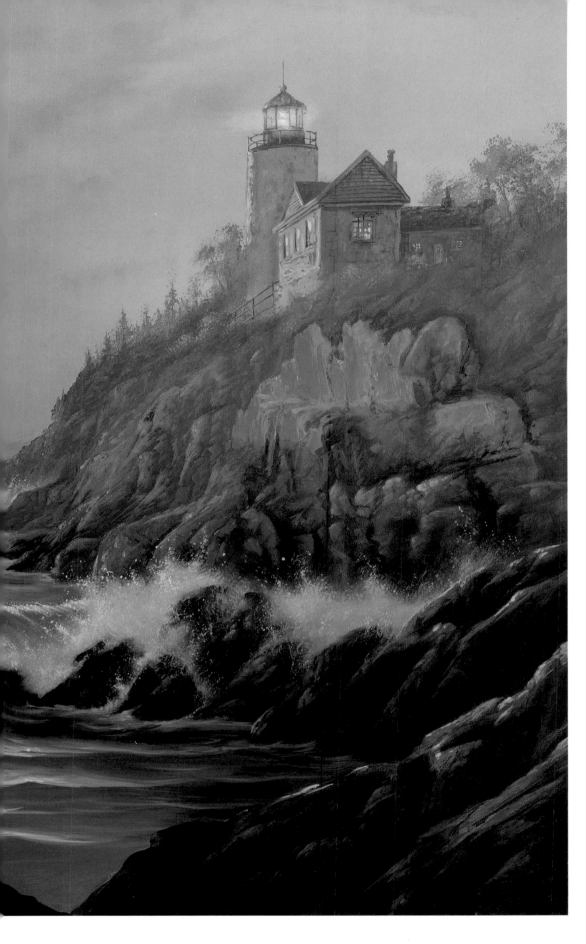

THE EVERCHANGING SEA

I remember when I was little we would lie on our backs and look at clouds, watching the shapes they took on and imagining we could recognize them as animals and people and castles and monsters and …

2000
24in x 36in (61cm x 91cm)
Available as limited-edition prints, greetings cards

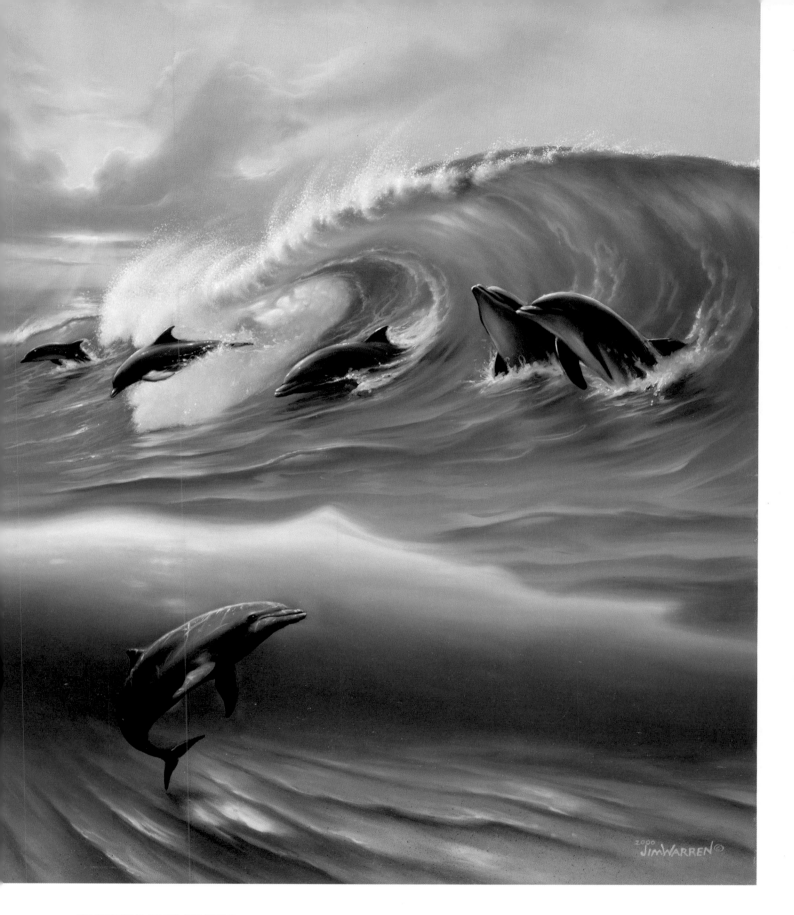

SURFIN' DOLPHINS

Dolphins are fun to paint as they seem to be enjoying themselves all the time.

2000

24in x 30in (61cm x 76cm)

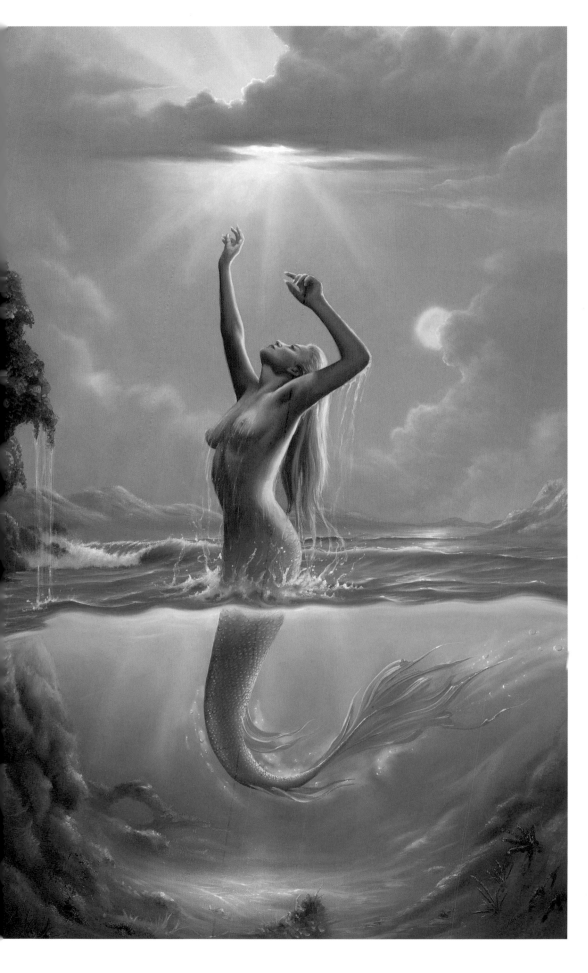

REACH FOR THE SUN

I get a lot of letters and e-mails these days from people telling me how much I have inspired them with my art. These messages give me very great pleasure because I myself have had important inspirations throughout my life, and so I feel as if now I am in a way paying back what I owe. This painting was inspired by those few artists who have made painting the beautiful underwater world a true artform.

1999

24in x 36in (61cm x 91cm)

Available as limited-edition prints

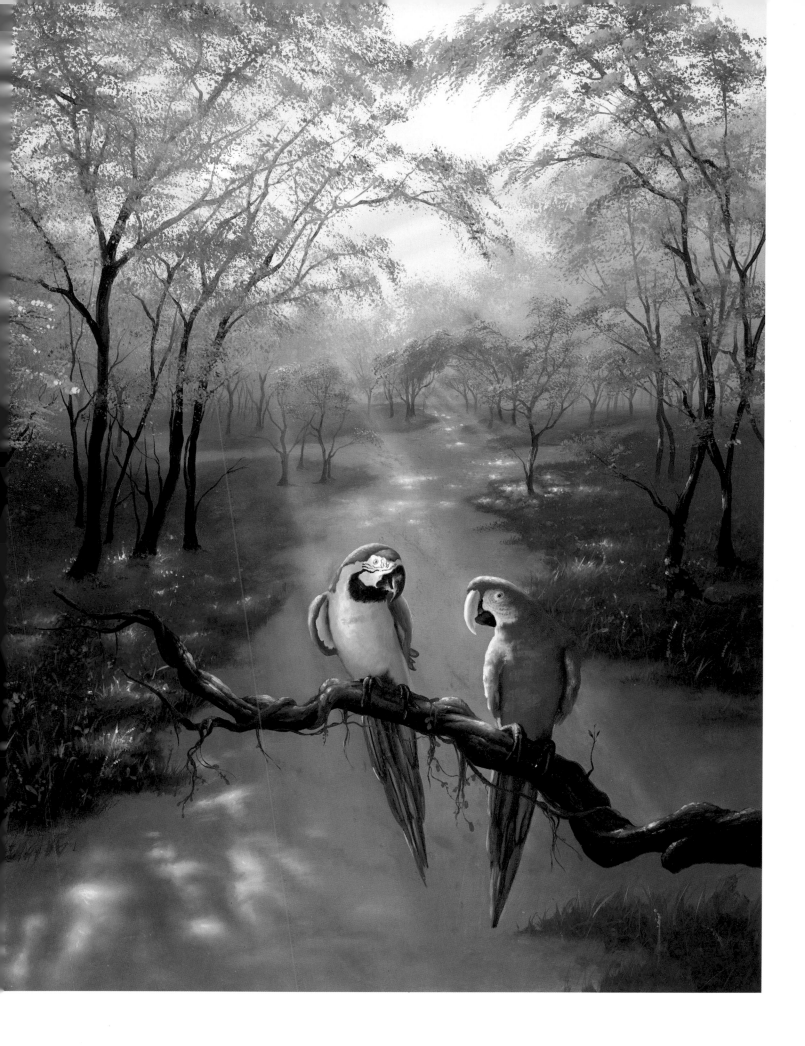

COLORS OF THE RAINBOW *(left)*

Although I have at times painted 'environmental message' pictures that were shocking, I have found that sometimes simply showing the beauty of Nature herself is the best environmental message of all.

2000

22in x 28in (56cm x 71cm)

Available as limited-edition prints

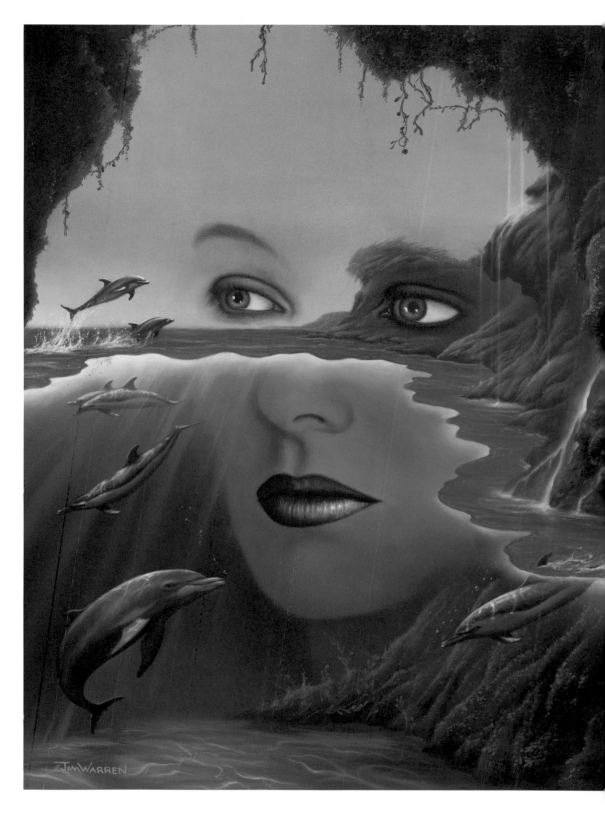

FRIENDS OF MOTHER NATURE

Friends are so important, and I could imagine Mother Nature having as her best friends some of the friendliest creatures on earth, the dolphins.

1995

24in x 30in (61cm x 76cm)

Available as limited-edition prints, puzzles, greetings cards

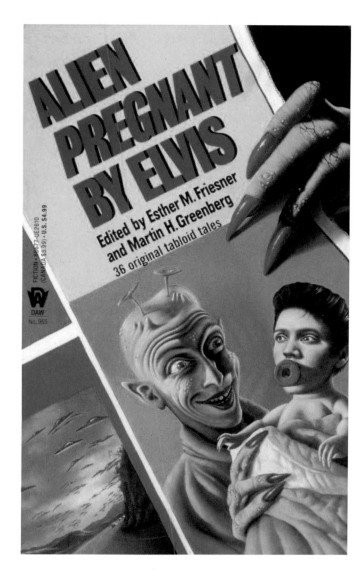

list of works

ALIEN PREGNANT BY ELVIS

This was done as the cover for the anthology edited by Esther Friesner and Martin H. Greenberg (DAW Books), and is possibly my favourite of the many book covers I did. Not only was it a lot of fun to do but I enjoyed making a commentary on the trashy supermarket tabloids that we strangely call 'reading material', and the ridiculous lengths they go to for a front-page story. OK, sure, I find myself reading a few while waiting in line at the supermarket …

1989

24in x 36in (61cm x 91cm)